THE CAPITALS
OF THE
CONFEDERACY

THE CAPITALS
OF THE
CONFEDERACY
A HISTORY

MICHAEL C. HARDY

Published by The History Press
Charleston, SC 29403
www.historypress.net

Copyright © 2015 by Michael C. Hardy
All rights reserved

Front cover, top, left to right: Phifer House, Charlotte, North Carolina. *University of North Carolina–Charlotte*; old customshouse, Richmond, Virginia. *Library of Congress*. Bottom, left to right: Virginia Statehouse, Richmond, Virginia. *Library of Congress*; Sutherlin Mansion, Danville, Virginia. *Michael C. Hardy.*

First published 2015

Manufactured in the United States

ISBN 978.1.62619.887.6

Library of Congress Control Number: 2015931110

Notice: The information in this book is true and complete to the best of our knowledge. It is offered without guarantee on the part of the author or The History Press. The author and The History Press disclaim all liability in connection with the use of this book.

All rights reserved. No part of this book may be reproduced or transmitted in any form whatsoever without prior written permission from the publisher except in the case of brief quotations embodied in critical articles and reviews.

Contents

Introduction	7
1. Montgomery, Alabama: February 4 to May 21, 1861	11
2. Richmond, Virginia: May 1861 to July 1863	31
3. Richmond, Virginia: July 1863 to April 2, 1865	59
4. Danville, Virginia: April 3 to April 10, 1865	76
5. Greensboro, North Carolina: April 14 to April 15, 1865	83
6. Charlotte, North Carolina: April 19 to April 26, 1865	91
7. The Flight of Jefferson Davis: South Carolina to Georgia, April 26 to May 10, 1865	100
8. Looking for the Capitals of the Confederacy	104
Notes	115
Index	125
About the Author	127

Introduction

Montgomery, Alabama, ruled the realm of cotton production. Richmond, Virginia, profited mightily from the slave trade. Neighboring Danville was sovereign of the tobacco industry. Greensboro, North Carolina, was an education metropolis, while Charlotte, North Carolina, bore witness to the first gold rush in the United States. Besides their locations in the southern portion of the United States, these historic cities do not seem to have many shared characteristics except that each of them served as a capital of the Confederate States of America.

In the 1860s, Americans experienced the most wrenching of disasters—a civil war. Southern states declared their independence, while the Northern states argued that the Union was perpetual. In the midst of the upheaval, the new nation that was formed, the Confederate States of America, struggled to create a functioning governing body. One of the Confederacy's most pivotal choices concerned the location that should serve as its capital. It was actually a decision that would have to be made repeatedly throughout the brief, tumultuous lifespan of the Confederate States of America. As the government was moved, for either strategy or safety, a new city became the capital of the Confederacy, with some sites holding the title for long stretches of time and others just for a matter of days.

Not every place in which Jefferson Davis signed a document or spent the night can be considered a Confederate capital. To hold this distinction, the site must have been the scene of official business: meetings of the Confederate cabinet, issuance of official proclamations or other activities

Introduction

of the various branches of its government. Montgomery and Richmond were chosen by the Confederate Congress and Danville, Greensboro and Charlotte by the fortunes of war. Many people over the decades have decreed that Danville was the "last capital of the Confederacy." Yet Davis and the Confederate cabinet continued to meet and even attempted to dictate policy in both Greensboro and Charlotte, hoping to keep alive the struggle for Southern independence. In Charlotte, offices were established, and in contrast to Danville and Greensboro, the entire cabinet met and advised Davis to surrender. Today, most of the cities that were, for any amount of time, hosts to the Confederate government are proud of their role in history. Each of the cities that served as a capital of the Confederacy was irrevocably changed, in some way, by the war.

Montgomery was a prosperous town prior to the war. Cotton was truly king there. Yet the war brought blockaded ports and a government that demanded agricultural land to produce more foodstuffs and less cotton and tobacco. The war hurt the local economy, and it took several years to recover.

Richmond, or a large section of it, was a charred ruin by April 3, 1865. As capital of the Confederacy, Richmond was thrust upon the world's stage. While the war brought new businesses and new jobs, inflation soared, and many of the city's citizens and refugees alike went hungry. The population is estimated to have quadrupled during the war years. As the Confederate government fled the city, fires were set to deprive the enemy of cotton, tobacco, munitions of war and the use of bridges. It would take decades to recover.

Danville was also an up-and-coming town in the 1860s, a town in which tobacco ruled. However, as in Richmond, war affected industry, as many of the tobacco warehouses were converted into Confederate hospitals and Federal prisoner of war facilities. Federal soldiers did visit the city as the Confederate government fled toward Greensboro, but Danville largely escaped the destruction wrought in Richmond. Indeed, the war increased the demand for tobacco, and Danville was soon riding the ups and downs of a postwar national economy.

Greensboro had its share of buildings repurposed by state and Confederate forces and more than its fair share of refugees, but the war did have a positive effect on the city. For years, citizens had been clamoring for a railroad connecting Greensboro with Danville. The loss of other rail lines in the South finally forced the government to take action, and the Piedmont Railroad was finished in 1864.

In Charlotte, the change was also primarily one for good. Charlotte was still a frontier town in the 1860s, the smallest town to serve, albeit briefly,

Introduction

as a Confederate capital. The war brought people to Charlotte, people who saw that the area had much to offer. Catapulting off the industries established during the war, Charlotte quickly grew into a leading part of an industrialized New South.

The war also had profound effects on the local populations of each place that served as a Confederate capital. A tourist only needs to visit places like the Confederate sections in Oakwood and Hollywood Cemeteries in Richmond or the National Cemetery in Danville to be reminded of the enormous cost of our great national tragedy.

Each of these places inspired at least one book that examines the war years. William Rogers Jr. penned *Confederate Home Front: Montgomery During the Civil War* (1999). Coupled with William C. Davis's *A Government of Our Own: The Making of the Confederacy* (1994), it gives readers a fascinating, detailed account of Montgomery and the formation of the Confederate States of America. There is a vast selection of tomes about Richmond and the war. The more current and helpful are Emory M. Thomas's *The Confederate State of Richmond: A Biography of the Capital* (1971 and 1988) and Ernest B. Furgurson's *Ashes of Glory: Richmond at War* (1996). Since Richmond was the most important Confederate capital and, arguably, the most important of the cities in the South during the war years, several aspects of the wartime history have been explored in other books. Rebecca Barbour Calcutt's *Richmond's Wartime Hospitals* (2005) is such an example. There were many people in Richmond penning diaries during that time. Some of the most insightful are John B. Jones's *A Rebel War Clerk's Diary at the Confederate States Capital* (1935); *Inside the Confederate Government: The Diary of Robert Garlick Hill Kean* (1957), edited by Edward Younger; Judith W. McGuire's *Diary of a Southern Refugee During the War* (1867); and Phoebe Yates Pember's *A Southern Woman's Story: Life in Confederate Richmond* (1959). Danville has a couple of fine books. These include F. Lawrence McFall Jr.'s *Danville in the Civil War* (2001) and John H. Brubaker III's *The Last Capital* (1979). Undoubtedly, Greensboro would be the weakest link in terms of scholarship. There is no book exclusively dedicated to Greensboro and the war. Readers can, however, learn much from Robert Dunkerly's *The Confederate Surrender at Greensboro* (2013) and Ethel Arnett's *Confederate Guns Were Stacked at Greensboro, North Carolina* (1965). The most recent look at a Confederate capital is Michael C. Hardy's *Civil War Charlotte: Last Capital of the Confederacy* (2012). Readers wanting more information about the flight of the Confederate government from Charlotte should seek out Clint Johnson's *Pursuit: The Chase, Capture, Persecution and Surprising Release of*

Introduction

Jefferson Davis (2008) and Michael C. Ballard's *A Long Shadow: Jefferson Davis and the Final Days of the Confederacy* (1997).

While each of those places has at least one book dedicated to the war years, no other work has attempted to tie together the places with the common bond that brought them together. That common bond was the government of the Confederate States of America. This is the purpose of the book you hold in your hands: to give a glimpse of the history behind each place that served as a Confederate capital. It also reveals how profoundly these communities were affected by the days, weeks or years during which the Confederate government took up residence there.

Like any other project, this one stands on the shoulders of others. I am indebted to the authors mentioned. And as always, a special thank-you to Elizabeth Baird Hardy. I would be nothing without you.

Chapter 1

Montgomery, Alabama

February 4 to May 21, 1861

For the second time in just over a month, the peals of the cannon and the cheers of the multitudes ripped through the air in Montgomery, Alabama. The first such celebration had erupted on January 11, 1861, when delegates to a state convention met in the capital to take Alabama out of the Union. Now, on February 18 on the steps of the statehouse in Montgomery, Jefferson Davis was sworn in as provisional president of a new nation. Many observers felt that Montgomery should become the permanent capital of the Confederate States of America.

Montgomery was a relatively new city. Located on a bend in the Alabama River, the area was settled in 1814 and originally called New Philadelphia. There was a hope that New Philadelphia might become the capital of the new state of Alabama, but that honor went to Tuscaloosa instead. In 1819, New Philadelphia merged with the nearby communities of Alabama Town and East Alabama to form Montgomery, which was officially incorporated in 1837. The new town was named in honor of Revolutionary War brigadier general Richard Montgomery, killed in 1775 at the Battle of Quebec. The town of Montgomery was located in Montgomery County, which actually had a different namesake than the city. The county was created by the Mississippi Territory General Assembly on December 6, 1816, and named in honor of Major Lemuel Montgomery, who fell at the Battle of Horseshoe Bend in 1814. In 1846, the capital of Alabama was moved from Tuscaloosa to Montgomery.

Cotton was truly king in Montgomery. At first, it was shipped from Montgomery to Mobile via steamboats on the Alabama River. In 1851, the

The Capitals of the Confederacy

Montgomery and West Point Railroad was completed, linking Alabama and Georgia. This line eventually ran to Atlanta, Columbus and the rest of the South. Three other lines out of Montgomery were under construction, including an almost-finished railroad connecting to both Mobile and Pensacola. The population of the city was 8,843, with 4,502 of those being slaves. Montgomery was the second-largest city in Alabama, following Mobile. Yet at the same time, thanks to the abundant cotton fields in the surrounding county, Montgomery was one of the richest cities in the South. One historian wrote that the land value in surrounding Montgomery County was estimated at $51 million.[1]

To those delegates either coming to the state convention or participating in the formation of the provisional Confederate government, Montgomery had much to offer. There were three hotels, including the luxurious Exchange Hotel. Added to this were an unknown number of boardinghouses. Montgomery had two banks, four newspapers, two bookstores, fifteen clothiers, five confectioners, four restaurants, thirty-four grocers, a half dozen druggists, two dozen doctors, a dentist and separate hospitals for both whites and blacks. The city boasted a half dozen jewelers, four slave traders, a dozen or more seamstresses, a half dozen milliners, a gunsmith and places to have either a portrait painted or a photograph taken. There were several private militia groups, seven Masonic Lodges, three Odd Fellows Lodges, a gym, a theater and a half dozen churches, including a Jewish congregation that was in the process of building a new synagogue. "Montgomery in 1860 was a place of wealth, architectural taste, and commercial vigor," wrote William Rogers in his history of the city.[2]

Perched atop Goat Hill was the state capitol. The original building had burned in December 1849, just two years after construction was completed. On October 1, 1851, the Alabama legislature met in the rebuilt Greek Revival–style building for the first time. Almost ten years later, secession convention delegates from across the state convened in the House chamber and, on January 11, 1861, voted to take Alabama out of the Union. Upon hearing the news, Montgomery citizens stormed the building, cheering the decision. A state flag made by local women was raised on the roof of the capitol, and a cannon on the capitol grounds was fired by Miss C.T. Raoul, joining the roar of other cannons and the bells ringing across the city.[3]

While the major newspapers of the era reported the secession of Alabama, Montgomery was soon thrust onto the international stage. Longtime political differences between the sections of the United States came to a head with the election of Abraham Lincoln in 1860. Believing that the election of

A History

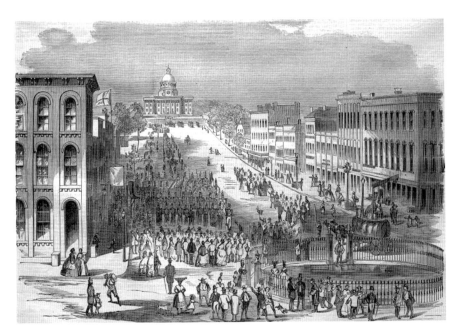

This view would have greeted most of the delegates as they moved almost daily from their hotels and boardinghouses to the Alabama state capitol on Goat Hill. *Library of Congress.*

a member of the radical Republican Party to the presidency would lead to further oppression, South Carolina took the first step and passed an ordinance of secession on December 20, 1860. Other states in the Deep South quickly followed, including Florida, Georgia, Alabama, Mississippi and Louisiana.

Taking the lead, South Carolina representatives recommended a meeting of Southern states take place in Montgomery prior to Lincoln's inauguration, which was scheduled for March 4. Secession convention delegates in South Carolina elected commissioners to go to the other Southern states on January 2 to encourage them to adopt their secession ordnances, and on January 5, they elected eight delegates to attend the convention in Montgomery. It was the proposal of the delegates in South Carolina that each state elect a number of delegates to the convention based on the number of senators and representatives in the United States Congress. When Alabama passed its ordinance of secession, there was a resolution officially inviting the other states to meet on February 4 in Montgomery.[4]

And so the delegates converged on Montgomery. Alabama's Robert Hardy Smith was one of the first, arriving from Mobile on January 30 and

staying with a local family. Portions of the South Carolina and Mississippi delegations arrived on February 2 on the morning train. This group included Robert Barnwell Rhett Sr., the "Father of Secession," along with his cousin Robert Barnwell. These delegates found rooms at the Exchange Hotel, and upon hearing of their arrival, some members of the Alabama delegation in town came to greet them. The evening train brought other South Carolina delegates, including Christopher Memminger, as well as Georgia's Howell Cobb. They likewise found rooms at the Exchange. Delayed because of a derailment, a train bearing James and Mary Chesnut of South Carolina and much of the Georgia delegation, including Robert Toombs, Thomas Cobb and Alexander Stephens, did not arrive until after midnight. Many of those aboard that train also lodged at the Exchange Hotel. The Chesnuts found rooms at the smaller Montgomery Hall, as did Louisiana's Alexander DeClouet. Stephens, looking for even quieter rooms, stayed at Mrs. Elizabeth Cleveland's boardinghouse, located a couple of blocks from the Exchange Hotel.[5]

Located on the corners of Commerce and Montgomery Streets, the Exchange Hotel became the central meeting spot for attendees. An earlier building, the Madison House, occupied the site prior to 1846, when a group of businesses constructed the Exchange. The four-story brick building contained 124 sleeping rooms that could accommodate up to three hundred guests. There were billiard and barrooms described as "models of elegance and taste, with hardwood finish, in early English style, panelled with plate glass." The second floor boasted a gentlemen's reading room. There was also a ladies' parlor with a separate entrance. After the capitol had burned in 1849, the Exchange held the meetings of the state legislature until the building could be rebuilt. Now, its rooms were filled with some of the most learned and politically astute men from across the South.[6]

Many who met in the cigar smoke–filled rooms of the Exchange had already developed some type of agenda. Robert Barnwell Rhett had a draft of a constitution, based on the old United State Constitution but with several amendments. He expected at least a cabinet post, if not the presidency itself. Fellow South Carolinian Christopher Memminger likewise came with a draft of a constitution, one that had been anonymously published in a newspaper a few weeks previously. Some, like James Chesnut, believed that former secretary of war and United States senator Jefferson Davis should be the first president. Many in Alabama felt it should be their own William L. Yancey. Alexander Stephens thought perhaps Robert Toombs. Before the impromptu meeting broke up on February 3, some of the delegates

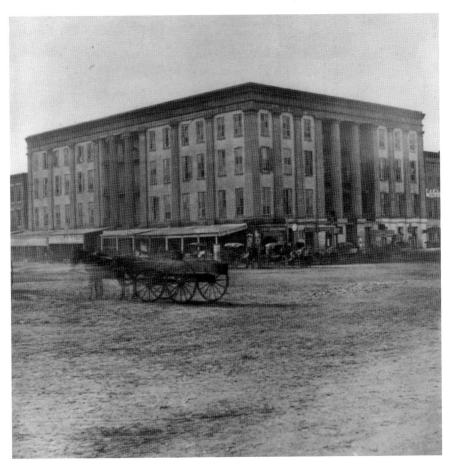

Constructed between 1846 and 1847, the Exchange Hotel in Montgomery was home to many of the South's leading politicians while they created the Confederate government. *Library of Congress.*

had agreed that Howell Cobb should preside over the proceedings, while Montgomery newspaper editor "Jonce" Hooper should serve as secretary of the convention. With that, the conversation ended, and the delegates returned to their rooms across town.[7]

For several days, rain had fallen in torrents in the area. Bridges were out, and more than one delegate noted the swollen Alabama River. Yet as the delegates made their way up the hill to the statehouse, the sun broke through the clouds, providing some warmth to the cold winter morning. After climbing the steps leading to the portico, delegates passed into the entrance hall. Straight ahead were the doors that led to the state Supreme

Court chambers. After ascending the stairs and entering the rotunda, the men could look up at the dome two floors above them. The House chamber was off to the right of the rotunda, and the Senate chamber entrance was to the left. Just a few days earlier, the Alabama Senate granted the convention delegates permission to the use the room. The walls, usually bare, had been decorated with paintings of George Washington, John C. Calhoun, Andrew Jackson, Henry Clay and William L. Yancey, among others. Delegates and visitors were also provided with two tables of refreshments, including cold meats, bread and fruit.[8]

Even though there were a few delegates yet to arrive, at noon on February 4, William P. Chilton, leader of the Alabama delegation, called the convention to order. Chilton next moved that South Carolina's Robert Barnwell be voted in as acting president, which was approved unanimously. After making a few remarks, Barnwell called upon Reverend Basil Manly to offer an invocation. After the delegates presented their credentials, Rhett called for the election of a permanent president and moved that Howell Cobb be accepted by acclamation, which carried. Howell was escorted to the chair and, after thanking his fellow delegates, moved toward electing a permanent secretary and appointing a doorkeeper and messenger. With the housekeeping finished, Alexander Stephens rose and moved that a committee of five be appointed to draft the rules of the convention. After the motion carried, Howell appointed a reluctant Stephens, against his wishes, to chair the committee, named four other committee members and then gaveled the first session closed. Barely an hour had passed, but without rules of conduct, no other business could take place.

Joining Stephens back at Mrs. Cleveland's boardinghouse that evening were Lawrence Keitt (South Carolina), James Harrison (Mississippi) and John Perkins (Louisiana). Thanks to the years Stephens had spent in the United States Congress, he was intimately familiar with the old House rules. A draft was soon written, and Stephens personally took it to the offices of the *Advertiser* and asked for fifty copies to be printed and delivered before noon the next day. The title chosen by Stephens was "Government of this Congress, Rules for the Government of this Congress." A few eyebrows would be raised on the morrow. Up until that point, they had simply been a convention. Stephens now considered them a congress.

Stephens placed a copy on each delegate's desk on February 5. At noon, Cobb called the meeting to order. The first item of business was the adoption of the rules, which passed with few alterations. After a few more housekeeping items, Memminger rose and offered a resolution authorizing

Cobb to form a committee to frame a provisional government. This committee was to be composed of two delegates from each state. Several other resolutions were quickly offered, and one delegate quickly rose and asked the chamber to be cleared of visitors and to go into closed session. The crowded galleries emptied of disappointed spectators and reporters. One of the latter complained that the chamber became a "temple of mystery and birthplace of liberty." For the rest of the afternoon, the delegates haggled over details. Finally, the Memminger motion passed.[9]

Twelve men headed back to Stephens's room and adjoining parlor at the Cleveland boardinghouse and commenced work that evening. Using the old United States Constitution as their framework, the committee of twelve spent the next day and a half hammering out a document to serve as a provisional constitution until a permanent constitution could be created. While they worked, their colleagues enjoyed some of the best hospitality that Montgomery could offer. Local elite—including John G. Winters, Thomas Watts, William Pollard, James Ware and others—put on scrumptious feasts and entertained the out-of-state guests at their opulent homes in Montgomery.[10]

Georgia's Howell Cobb presided over the delegates from the Deep South states who met in the Alabama state capitol and drafted a provisional constitution. *Michael C. Hardy.*

At 11:00 a.m. on February 7, Cobb gaveled the meeting in the Senate chamber to order. Since the proposed provisional constitution was still at the printers, a recess was called. After dispatching the food on the tables, the delegates reconvened, and once they had dispensed with some more mundane matters, Memminger moved that that they go into closed session. Still without the printed copies, Memminger read from a draft, and then the group recessed for the day. The next morning dawned warm, a contrast to the freezing temperatures of earlier in the week. Once again, the delegates made their way up Market Street to the statehouse. Copies arrived from the printer, and work soon commenced. Throughout the day and into the evening, the delegates wrangled over the text of the document. After nine hours of debate, the document was approved unanimously. The delegates adjourned, agreeing to be sworn in the following day with members of the public as witnesses and then to take up the election of a provisional president and vice-president in secret. Montgomery greeted the news once again with cannon fire, locomotive and steamboat whistles and crowds of exuberant people.[11]

Behind closed doors and in the bar at the Exchange Hotel, quite a few names had been batted about as contenders for the presidency. Rhett, Stephens, Cobb and Howell were all front-runners. In the end, the new provisional congressmen chose Mississippi's Jefferson Davis, who was not even a delegate at the convention, as president. Davis was seen as a moderate, someone who might be able to coax the border states, like Virginia, into the new Confederate States of America. As vice-president was a man who had originally voted against secession, Georgia's Alexander Stephens, who had done more work than anyone else during the convention, authoring the governing rules and playing a large part in drafting the provisional constitution. While there were dissenters with the selections, everyone either voted in support or held his tongue.

Stephens was sworn in just after 1:00 p.m. in the statehouse on February 11, 1861. It was his forty-ninth birthday. Regular business took the rest of that day. That evening, a group of citizens, led by a brass band, serenaded the new vice-president with "Dixie" and "Marseilles." Stephens was asleep at the time but managed a brief speech upon waking. The throng then moved down the streets of Montgomery looking for other dignitaries to whom they could sing. At the same time, other citizens met at Estelle Hall and agreed to offer the upper floor of the Montgomery Insurance Building as office space for the Confederate government while beginning the hunt for a suitable executive mansion for the incoming Davis. There had already been talk

of moving the Confederate capital to Atlanta. The people in Montgomery realized the importance, especially in an economic sense, of keeping the capital in Alabama. There was even talk of constructing a new Confederate capitol building in Montgomery, at a cost of $1 million. "I opine that no place can be better adapted for the permanent location of Congress than Montgomery, provided, nevertheless, that the City Council should take immediate steps toward paving the streets, or at least toward furnishing them with draw-bridges or passenger steamboats," quipped one newspaper reporter. This same reporter later added that all of this speculation had driven up the property prices in the city.[12]

It had taken time for word of his election to reach Davis in Mississippi. A messenger found him in his rose garden at Brierfield in Mississippi late on February 9. The president-elect departed on February 11 and arrived at the depot in Montgomery around 10:00 p.m. on February 16. Davis made a few remarks as he stepped from the railroad car, and the cannons once again roared and bells pealed. From the depot, a carriage took Davis and William Yancey to the Exchange Hotel, where once again the crowds implored Davis for a speech. He stepped onto the second-floor portico to address the crowd. After he returned to his room, the crowds continued to cry for more speeches, and Yancey soon appeared. "The whole city is agog on account of the arrival of President Davis," Thomas Cobb wrote home to his wife. "This is a gay and handsome town of some 8000 inhabitants and will be not an unpleasant residence," Davis wrote home to his wife, Varina, a couple of days following his arrival.[13]

February 18 dawned cloudy with frost. Around 12:00 p.m., Davis, Stephens, Reverend Basil Manley and Captain George Jones, Davis's military escort, emerged from the Exchange Hotel and stepped into a waiting carriage. A brass band led the procession, playing "Dixie," followed by militia companies, Davis's barouche (being drawn by six gray horses) and then the carriages of other dignitaries, followed by a moving mass of people. Some estimated the crowd in Montgomery that day between six thousand and eight thousand people. Upon arriving at the Alabama Statehouse, Davis and the rest of the elected officials moved inside and upstairs to the Senate chamber. Davis was formally introduced to the others, many of whom he had known for years. On a table was the official Provisional Confederate Constitution, which the congressional members were in the process of signing. Shortly thereafter, the congressmen filed down the curved staircase and took their places outside on a platform. Davis, Stephens, Howell Cobb and Reverend Manley then proceeded onto the portico. Manley opened with an invocation, and then, at

The Capitals of the Confederacy

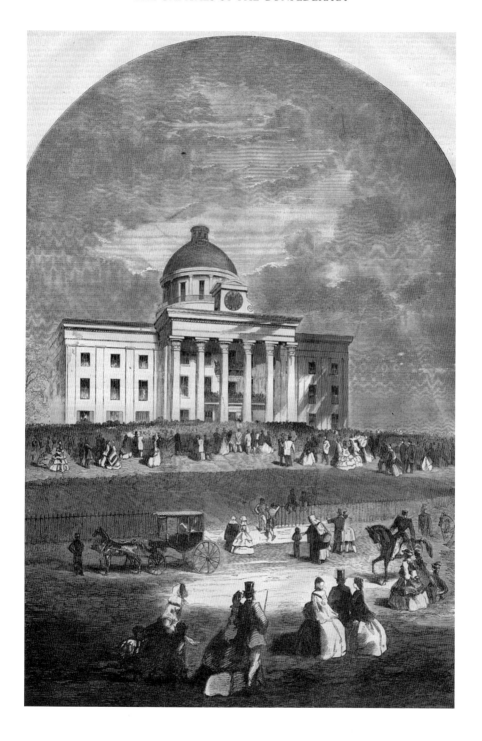

1:00 p.m., to a cheering throng, Howell Cobb introduced Jefferson Davis. One newspaper reporter thought that it was "the grandest pageant ever witnessed in the South." Davis spoke for eighteen minutes. Then Howell Cobb took from the table a Bible, holding it out toward Davis. Davis placed his hand on it and repeated these words: "I do solemnly swear that I will faithfully execute the office of President of the Confederate States of America, and will, to the best of my ability, preserve, protect, and defend the constitution thereof." Davis finished with "So help me, God," and leaned down to kiss the book, continuing to repeat the last four words.[14]

While there was some cheering, and flowers were thrown toward Davis, the presidential party and other representatives retreated quickly back inside the statehouse to take care of some minor business. Two soirees were held in Montgomery that evening, one at Estelle Hall and the other at the concert hall. The public was invited to both. At Estelle Hall, Davis stood beneath an arbor of flowers and evergreens, greeting well-wishers. "Every body and his wife was there," wrote Thomas Cobb to his wife. Even two of Mary Lincoln's sisters were present for the festivities. Local infants were named for the new president, and there was a bold proposal to rename Montgomery's Market Street "Davis Avenue."[15]

With the evening's festivities over, everyone went back to work. A new nation was being created out of nothing, with very few resources. Davis soon set about filling the positions of the Confederate cabinet. Christopher Memminger became treasury secretary. Leroy Walker, an Alabama state legislator and judge, accepted the position of secretary of war. Florida's Stephen Mallory, whom Davis knew well from the United States Senate, became the secretary of the navy. Also from the old Senate came Judah P. Benjamin, as attorney general. Robert Toombs eventually accepted the position of secretary of state, but only temporarily until someone else could be found. John H. Reagan, described as a "planter, Indian fighter, surveyor, lawyer and judge," and a Texas congressman, was eventually persuaded to accept the position of postmaster general.[16]

While Davis worked on appointing the first Confederate cabinet, Memminger set to work opening offices in the Montgomery Insurance Building, soon to be styled the Government House. The three-story brick building was one block from the Exchange Hotel. The building was empty,

Opposite: On February 18, 1861, Jefferson Davis was inaugurated as provisional president of the Confederate States of America in a ceremony held on the portico of the Alabama state capitol in Montgomery, Alabama. Harper's Weekly, *March 9, 1861.*

The Capitals of the Confederacy

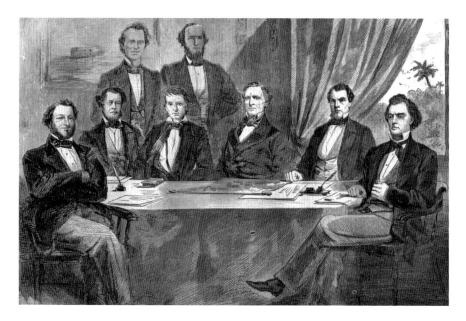

An artist's rendering of the original Confederate cabinet. The members are (seated, from left to right) Judah Benjamin, Stephen Mallory, Christopher Memminger, Alexander Stephens, John Reagan and Robert Toombs. Standing are Jefferson Davis and LeRoy Walker. Harper's Weekly, *June 1, 1861.*

and Memminger's first appointment, Henry Capers, set about acquiring a table, a desk, a chair and stationery just an hour before he had advertised the opening. A piece of cardboard lettered "Treasury" was hung on the door, and an empty vault sat in the corner. That same day, February 19, the Confederate Congress began the process of authorizing the departments that would fill the empty office space that only Capers occupied. Davis signed the bills into law on February 21. Eventually, Davis had offices on the second floor, while Toombs established the State Department on the third floor.[17]

Montgomery was besieged with office seekers. They came by the hundreds, looking for jobs with the new government. "Everybody who comes here wants an office," famed diarist Mary Chesnut chronicled on February 25. "And the many who of course are disappointed raise the cry, against the few who are successful, of corruption." Thomas C. De Leon, a former clerk in the bureau of topographical engineers, wrote that "Montgomery was Washington over again, only on a smaller scale, and with the avidity and agility in pursuit of the spoils somewhat enhanced by the freshness of scent." The operations of the Confederate government grew so rapidly that,

by the end of March, additional office space was needed. Reagan moved the offices of the postal department into the second floor of a building at the northeast corner of Perry and Washington Streets. It was here that Reagan likely established his school for officers and postal clerks. Classes ran two hours every evening. Other departments moved into the Noble and Brothers building, across from the government building on Commerce Street and the second floor of the Figh building.[18]

Sir William Howard Russell, considered the first modern war correspondent, arrived in Montgomery to report on events for the *Times* of London. In his diary, Russell recalled visiting

> "*Jeff Davis's State Department*"—*a large brick building…with a Confederate flag floating above it. The door stood open, and "gave" on a large hall whitewashed, with doors plainly painted belonging to small rooms, in which was transacted most important business, judging by the names written on sheets of paper and applied outside, denoting bureaux of the highest functions. A few clerks were passing in and out, and one or two gentlemen were on the stairs, but there was no appearance of any bustle in the building.*[19]

Military companies likewise filled the capital. Many of them were quartered at the fairgrounds or, when heavy rains flooded the area, one of the warehouses on the south bank of the Alabama River. According to a history of the Fifth Alabama Infantry, the fairgrounds were christened Camp Jeff. Davis. At times, various independent companies marched to town and paraded in front of hotels or government buildings. Chronicling in his diary, William Russell noted that a company of artillerymen was tramping through the streets, followed by a crowd of cheering people. The band was playing the quickstep "Dixie," and the soldiers were dressed in "coarse gray tunics with yellow facings, and French caps." The men carried muskets and were followed by artillery pieces but had no caissons.[20]

On March 4, just a little after 4:00 p.m., Miss Letitia Tyler, granddaughter of former United States president John Tyler, unfurled the national Confederate flag above the statehouse in Montgomery for the first time. She was accompanied by six other young ladies, together representing the seven Confederate states. As the city clock chimed four, a cannon was fired, and "Dixie" played as the flag went up the pole. "All [of] Montgomery…including all members of the government—stood bareheaded as the fair Virginian threw that flag to the breeze," recalled

De Leon. It was the same day that Abraham Lincoln was inaugurated in Washington, D.C. It was also the same day that Davis held his first cabinet meeting, gathering in room 22 at the Exchange.[21]

For the time being, Davis continued to occupy his room and adjoining parlor at the Exchange Hotel. One historian described the room as having a table in the center, with an oilcloth draped over it. The top of the table was covered with manuscripts, "books, maps, samples of military cloth, hats, swords, buttons, and all other manner of military paraphernalia." Also found in the room were a sofa, chairs, a mirror and paintings, including ones of Henry Clay, Daniel Webster, John C. Calhoun and Napoleon. Outside the room was an usher or clerk, who passed cards on to Robert Josselyn, Davis's secretary. Upon granting entrance, Josselyn announced visitors, who passed into the room. "Members of the Cabinet and high officials came in and out without ceremony, to ask questions and receive very brief replies," recalled De Leon. Even after formal offices were opened in the government building, Davis still received visitors and conducted business for a time at the Exchange Hotel. Davis was always busy. Caleb Huse, who was sent to Europe to procure arms for the Confederate army, recalled being seated next to Davis as the president read correspondence, received visitors and conversed with Huse. Years later, Huse confessed that he could not recall any of their conversations. Davis probably could have said the same.[22]

Varina Davis, the First Lady of the Confederacy, arrived in Montgomery on March 1. Jefferson Davis was eighteen years her senior, and the two had a sometimes rocky relationship. She had tarried in Mississippi for two weeks, preparing the family for the move. Mary Chesnut was the first to pay her a social call on March 2. The women had become friends while their respective husbands served in the United States Senate. Mary wrote that Varina "met me with open arms. What a chat that was, *two* hours." On March 6, Varina held her first levee as the First Lady of the Confederacy. She left the following day, returning to Mississippi to gather more personal belongings.[23]

Work continued on formatting the new Confederate government. Davis appointed commissioners to Great Britain, France and the United States. At the same time, the Congress hammered out a permanent constitution, finished it by March 11, submitted it to the states for ratification and adopted characteristically American laws of war for both their diminutive land and sea forces. The wording of letters of marque for privateers was refined, and commissions went forth to both former United States Army officers and private citizens who were willing to take up arms in defense of the Southern cause.[24]

Other men arrived and were appointed to various positions. Samuel Cooper, who had just resigned as adjutant and inspector general in the United States Army, was appointed to the same position in the new Confederate army, with the rank of brigadier general. Lucius B. Northrop was placed in charge in the commissary department, and Abraham C. Myers was given the quartermaster department, while David De Leon became surgeon general. Several of these men combined their resources and rented a house in Montgomery, calling it "the Ranche." The "piazza soon became the favorite lounging-place in the evening of the better and brighter elements of a floating population," recalled De Leon. The "latest papers and news 'from across'" were discussed "as the blue smoke of the Havanas floated lazily out on the soft summer night, many a jovial laugh followed it and not infrequent prediction of scenes to come almost prophetic."[25]

Townspeople did more than just rent rooms or houses to the masses. Local doctors took care of sick troops free of charge; other citizens sought to establish a free library for politicians and soldiers alike. Local clothiers began making uniforms for officers, while booksellers carried the latest military manuals. One millinery even carried red, white and blue bunting used in the production of flags. The women of Montgomery formed themselves into a Ladies' Aid Society and began working. In early May, at the urgent request of Braxton Bragg in Pensacola, they sewed five thousand sandbags in just forty-eight hours. One group of ladies met in the basement of the Methodist Episcopal church every morning to sew uniforms or knit socks. Later, these same ladies cut notes for the treasury department.[26]

Jefferson Davis promised Varina that he would look for a permanent location for their family in Montgomery. In February, the Confederate Congress authorized the leasing of a house for the president. In mid-April, an 1830s house belonging to Edmund Harrison was secured at a cost of $5,000 per year, a sum that raised some concerns. The two-story Federal-style house was remodeled in 1855 to represent the more fashionable Italianate trend. Styled the "White House of the Confederacy," the house sat one block from the Government House and two blocks from the Exchange Hotel. Varina considered the house "roomy enough for our purposes…and looking toward the State Capitol." Varina returned via steamboat on April 14, and the family moved into the official residence the following day. Just one day later, Varina hosted her first dinner party, consisting of the Davises, Toombs, Stephens and a couple of others. Shortly thereafter, Varina instituted a levee every Tuesday. William Russell was invited to one of these receptions. He noted that the Davises lived in a "modest villa…painted white" and standing "in

THE CAPITALS OF THE CONFEDERACY

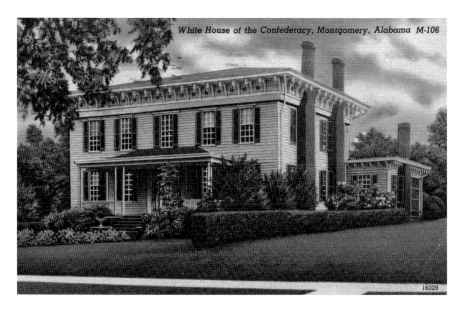

Constructed between 1832 and 1835, this was the Montgomery home that was rented by the Confederate government to serve as the first executive mansion for Provisional President Jefferson Davis. *Michael C. Hardy.*

a small garden." Russell found the door open and a servant waiting inside to take his name. After being presented to Varina, Russell noted that a few others had gathered in a "moderately-sized parlor" and that there "was no affection of state or ceremony in the reception." The president was rarely home. He left early and spent most of his time in the Government House. At other times, he could be seen working late at his office at home, the red glow of his lamp visible over the hedge from the street.[27]

With the creation of a provisional (and then permanent) constitution and a congress, along with the naming of cabinet posts and ambassadors to foreign governments, there was one issue above the others that weighed heavily on the minds of those meeting in Montgomery: the disposition of forts still controlled by Federal soldiers in Pensacola and Charleston. While Jefferson Davis professed over and over again that he did not want a war, either location seemed ready to erupt at a moment's notice. If anything, Davis wanted to wait until Lincoln took office, to give the new United States president a chance to negotiate, work out a deal and turn the forts over to the just-formed Confederate government. On several occasions, Davis wrote to South Carolina governor Francis Pickens, asking Pickens to rein in the South Carolina militia until the Confederate government chose to

act. Confederate commissioners in Washington found signs of war in early April. Warships were being fitted out at the navy yard, and rumors circulated that an expedition to relieve either Fort Sumter in Charleston or Fort Pickens in Pensacola would soon be underway. Later that same day, Lincoln notified South Carolina that he was resupplying Fort Sumter. On April 8, P.G.T. Beauregard, the post commander in Charleston, was ordered to halt local provisions being sent to the Fort. Davis and his cabinet then sent the Washington commissioners instructions. The resupply of Fort Sumter would be seen as an act of war.[28]

Davis met with his cabinet at the Government House on April 6. One correspondent considered that meeting "of a grave character" and reported that "serious conclusions were arrived at and warlike orders issued." The cabinet meeting kept the various heads of state busy until after midnight. For the next week or so, the cabinet met almost daily. On April 10, Beauregard was ordered to demand the surrender of Fort Sumter. If the demand was not met, Beauregard would then take the fort. On April 12, Confederate forces in Charleston opened fire, and thirty-four hours later, Fort Sumter capitulated. Almost hourly, messengers went back and forth between the Government House and the telegraph office located in the Winters building. At the same time, crowds gathered outside that office and those of local newspapers, waiting for word. Upon hearing the news, Montgomery was electrified. Cannons once again roared to life, and people took to the streets. Businesses and stores in Montgomery closed. Mayor Noble spoke to the crowd in front of the Winters building. That evening, a large group serenaded the Davises and Secretary Walker. Davis was ill, having overworked himself, but Walker appeared, announcing the surrender of Fort Sumter, and proclaimed that "the flag of the Confederate States [would be] raised upon the dome of the Capitol at Washington in three months." The crowd surged to the Cleveland boardinghouse, where Toombs was roused from his bed to speak to the masses. When additional details arrived the following day, the crowds again took to the streets, and the large flag made for Congress was seen floating in front of the Government House.[29]

Telegrams were soon pouring into Montgomery, congratulating Davis and the Confederate government on their recent victory. The firing on Fort Sumter, and Lincoln's subsequent call for seventy-five thousand troops to go into the Deep South states to crush the rebellion, succeeded in pushing many of the border states out of the Union. The Confederate Congress returned on April 29, answering the president's call for a special session. Davis addressed the provisional congress through a letter, stating that he

had convened Congress so that they could "devise the measures necessary for the defense of the country." That same Congress declared a state of war on May 3. Beauregard, the hero of Fort Sumter, arrived the following day. With him was the flag that flew over Fort Moultrie during the attack on Fort Sumter. Soon, the flag was hung behind the Speaker's chair in the Congressional chamber. A crowd of representatives and their wives returned to Montgomery, taking up residence once again in area hotels and boardinghouses or rented lodgings. Receptions, levees and dinner parties continued apace with the arrival of the politicians.[30]

There were many sites vying to become the permanent capital of the Confederacy. In March, the Alabama General Assembly proposed giving the Confederacy a ten-mile square piece of property near Montgomery for the capital. One editor from New Orleans believed the area should be christened the "District of Davis" and be an independent district. He believed that it would take six years to construct the necessary infrastructure for the new capital complex. Huntsville was deemed a "formidable rival" to the Montgomery location, as were Tuscaloosa, Selma, Shelby Spring and Spring Hill (all in Alabama). Tuscaloosa went so far as to send a delegation to Montgomery, offering to the Confederate government the buildings that once housed the Alabama capital. Atlanta was advanced more than once, and also in the mix were Nashville and Memphis in Tennessee; Pendleton, South Carolina; as well as Alexandria, Virginia, just across the Potomac River from Washington, D.C. On April 27, John Janney, president of Virginia's secession convention, sent Davis a copy of a resolution, inviting Davis and the "constituted authorities of the Confederacy" "to make Richmond…the seat of the Government of the Confederacy." South Carolina's William W. Boyce introduced a resolution to move the capital on May 1. Nothing came of the resolution, and on May 10, Francis Bartow introduced a new resolution. After considerable debate, the resolution passed, calling for Congress to adjourn on May 23 and reconvene in Richmond on July 20. Davis vetoed the resolution on the grounds that the executive and legislative branches of the government should not be separated. The resolution that had passed the Congress relocated only that body to Virginia. On May 20, the Congress debated the action again and moved that the entire Confederate government relocate to Richmond. The vote was six to three. Each Confederate state had only one vote. Davis signed the resolution on May 21, and Congress appropriated $40,000 to cover the cost of the move. With that, Congress adjourned, and the delegates boarded trains or steamboats and headed out of town.[31]

There were many reasons for the move. If Virginia or Maryland was going to be the site of the main military contest, then Richmond was a better place to direct that confrontation. Richmond was also better connected with rail lines and the Atlantic Ocean and was one of the leading industrial centers in the South. Plus, larger Richmond could better facilitate the numerous bureaus and offices of the government, structures that would need to be built in Montgomery. The population of Montgomery, according to one historian, had doubled in just three months. Some viewed a move to Richmond as a step toward occupying Washington itself. Moreover, Virginia was home to Washington, Jefferson and Madison, along with a great host of other patriots and Revolutionary War history. Finally, there was the issue of the climate. John B. Jones, a clerk in the War Department, chronicled on May 24 that Richmond had "a more congenial climate." Mary Chesnut believed that the living conditions alone in Montgomery "will move the Congress." Yet her husband, James, was "violently" opposed to the move, finding Montgomery "so central a position for our government." There were many more hesitant about the relocation, including Vice-President Stephens.[32]

Howell Cobb, in Atlanta, spoke to a crowd about the move:

> *If you wish to know why the Government was removed to Richmond, I can say, circumstances have arisen that have rendered it proper. We have received the Old Dominion into our Confederacy. Her soil will, perhaps, be the battle ground of this struggle. Her enemies are gathered around her to force her into subjection to their foul dictates. We felt it our duty to be at the seat of war. We wanted to let Virginia know that whatever threats or dangers were presented to her, filled our hearts with sympathy for her, which we are willing to exhibit, to show that there was not a man in the Confederacy who was afraid to be at this post on Virginia soil. We also wanted to be near our brave boys, so that when we threw off the badge of Legislators, we might take up arms and share with them the fortunes of war. We felt the cause of Virginia to be the cause of us all. If she falls, we shall all fall; and we were willing to be at the spot to be among the first victims. We are ready to say to Lincoln, when he attempts to put his foot on Virginia soil, "Thus far shalt thou come, no farther."*[33]

Davis rose on May 26 and, as was his custom, attended St. John's Episcopal Church. He later visited the Government House. That evening, his carriage took him to the depot, where he boarded a car containing Cooper, Walker, Toombs and other officials. Davis's leaving was largely kept

a secret, due to the possibility of assailants. The various departments were all boxing up papers and documents for the move. The final train bearing crates of papers, clerks and office seekers did not leave until the morning of May 30.

Montgomery's international prominence as the capital of a new nation quietly came to an end. It had lasted just over three months. In 106 days, in this cotton capital, Southern politicians had formed a provisional government, elected a provisional president who, in turn, appointed various heads of state, created fledging armies and a navy, drafted a permanent constitution, appointed emissaries to foreign governments and orchestrated a small but significant military victory at Fort Sumter, all the while dealing with hundreds of minute details. All of this took place in the Exchange Hotel and Montgomery Hall, the Alabama state capitol building, the Government House, Mrs. Cleveland's boardinghouse and several other smaller homes. Like many other towns and cities in the South, Montgomery was affected by the war. Many young men marched off to fight, and many never returned. There were at least two major hospitals in the city during the war, and a section of Oakwood Cemetery contains over 750 Confederate graves. There was also a Union prison in the area following the Battle of Shiloh in 1862. The hard hand of war itself did not arrive until April 1865, when Federal cavalry under Brigadier General James H. Wilson rode toward the city. Fleeing Confederates torched warehouses. Federals entered the city on April 12, and the United States flag flew above the capitol building later that afternoon.

Chapter 2

Richmond, Virginia

May 1861 to July 1863

Jefferson Davis spent three days crossing the Deep South en route to the new Confederate capital. Despite hopes to keep the journey quiet, word spread that the Confederate government was on the move. At places like Atlanta, Augusta and Wilmington, crowds called on the president to speak. The train arrived in Wilmington early on the afternoon of May 28. A local militia company was present to greet the train, along with a crowd "greater…than we had ever seen there before," chronicled a local newspaper, adding that the "ladies were out in full force." Davis made a few remarks but pleaded illness. Louis Wigfall of Texas addressed the crowd at length. The travelers were provided with a fresh engine and, by three that same afternoon, were on their way north. Davis spent that evening in Goldsboro and, while at dinner, was "thronged with beautiful girls, and many were bedecking him with garlands of flowers, while others fanned him." The following morning, he was back on his way to Virginia.[34]

Richmond had already been the scene of pivotal revolutionary moments in history. In 1775, Patrick Henry had stood before the second session of the Virginia Convention at St. John's Church in Richmond to give a speech. Sitting in that crowd were the likes of Thomas Jefferson, George Washington and Richard Henry Lee. Henry's "Liberty or Death" speech warned his fellow delegates to be wary of British assurance of goodwill, likening their overtures of peace to the kiss of a traitor. "We must fight!" Henry had thundered to the multitude of delegates. "I repeat it sir, we must fight! An appeal to arms and to the God of hosts, is all that is left to us…Is life so dear,

or peace so sweet, as to be purchased at the price of chains and slavery? Forbid it, Almighty God! I know not what course others may take: but as for me, give me liberty, or give me death!" The founders of this new republic were familiar with Henry and his call to action. Davis had even been quoted as using the famous "give me liberty, or give me death!" lines in a speech in Jackson, Mississippi, in 1857. Those very sentiments undoubtedly tugged the heartstrings of many in the congressional and presidential parties as they made their way into Richmond.[35]

While Montgomery was a new, recently settled Southern town, Richmond was one of the oldest. In 1607, the area was explored by the colonists from the Jamestown settlement. Land was purchased from the local Native Americans in 1609, and a fortified Indian village was renamed Nonsuch. Englishman Nathaniel Bacon moved to the Virginia colony in 1674 and settled in the James River area. Although appointed to the governor's council in 1675, Bacon led a rebellion against the governor, even laying siege to Jamestown. Bacon died suddenly of dysentery in October 1676, and his rebellion died with him. Almost a century later, the capital of the new state of Virginia was relocated from Williamsburg to Richmond. In 1785, Thomas Jefferson designed the new capitol building, the first Western Hemisphere public building constructed in the classical style.

Over the next seventy-five years, Richmond grew exponentially. In 1860, the population was 37,968, which included 11,739 slaves and 2,576 free persons of color. Richmond was the twenty-fifth-largest city in the United States and the thirteenth-largest manufacturer. There were 332 businesses listed in the 1860 census. Among those were 12 flour and meal mills in the city. One of those mills was considered the largest in the world. Added to this were 3 bakeries, 1 distillery, 1 brewery and 1 patented medicine–making company. Richmond boasted 52 tobacco companies, coupled with 7 tobacco warehouses and exchanges, 6 companies that manufactured tobacco boxes and 2 cigar makers. There was also 1 woolen mill, 1 paper mill, 4 rolling mills, 14 foundries and machine shops, 1 nail works, 6 companies that manufactured iron railing and at least 50 iron and metal works. Rounding out the business directory were cobblers, saddlers, coopers, carriage makers, blacksmiths, brick makers and bookmakers.[36]

Arriving Confederate politicians, family members and office seekers found several hotels, including the Exchange, Spotswood and the American, along with the Ballard House. There were four major banks with a combined capital of $10 million and thirty-three churches, including four African American, three Roman Catholic, three Jewish synagogues, one Quaker

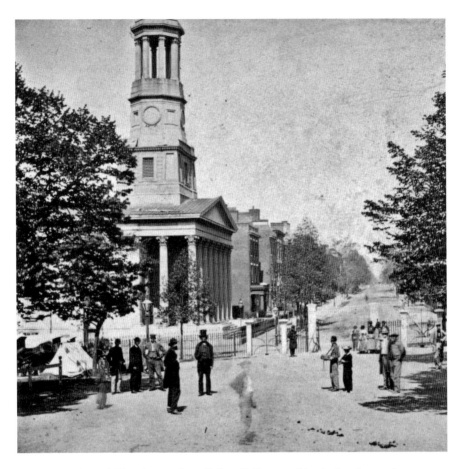

St. Paul's Episcopal Church was where Robert E. Lee worshiped when he was in Richmond and where Jefferson Davis was confirmed. Davis was attending a service here when he learned of Lee's being forced to abandon the entrenchments around Petersburg. *Library of Congress.*

Meetinghouse and one Universalist. A visitor could find six public and twenty-three private schools, along with the Medical College of Virginia and the Richmond Female Institute. The *Southern Literary Journal*, considered "one of the finest literary journals in the nation," was produced in the city. Richmond was also the nation's largest coffee market. There were five railroads, leading in all directions, and four daily newspapers.[37]

Unlike the Deep South states that composed the Confederate States, Virginia had waited to leave the Union. There were some who advocated secession early on, but many in the Old Dominion were lukewarm to the idea. It took the engagement in Charleston, with Lincoln's call for seventy-

five thousand troops to go into the Deep South states to crush the rebellion, to push Virginia out of the Union. When news arrived of Fort Sumter's fall, three thousand Richmond citizens took to the streets, and the Stars and Bars floated above the Virginia Statehouse as "Dixie" played. Virginia's governor John Letcher had the flag removed that same evening, and a state flag flew in its place. Letcher ordered the James River blocked at Norfolk on the next day, and on the day following, the Virginia legislature, meeting in a secret session, passed a secession ordinance. On April 19, a crowd estimated at ten thousand paraded through the streets, and once again, the Stars and Bars rose on the Virginia Statehouse flagpole. Former United States president John Tyler spoke to a crowd of secessionists that same evening, followed by Letcher. It was soon thereafter that the secession delegates proposed to the Confederate government that Richmond would make a fine capital for the new administration.[38]

A special train bearing Davis, Wigfall, Northorp and a few others arrived in Petersburg early on the morning of May 29. Boarding the train in Petersburg were Governor Letcher and Richmond mayor Joseph C. Mayo. At 7:25 a.m., the train pulled into the railroad station. The group was met by thousands of cheering well-wishers and a fifteen-gun salute—one cannon for each of the fifteen Southern states, according to one Richmond newspaper. Davis was then escorted via carriage four blocks through the streets of Richmond. "People rushed up and *would* shake hands with the President, many of them doing so with tears of heartfelt joy 'in eyes unused to weep,'" recalled one writer. Another citizen remembered, "Almost every house in the city was decorated with the Stars and Bars." The carriage bore Davis to the Spotswood Hotel, just recently opened at the corner of Main and Eighth Streets. Thomas W. Hoeninger, the manager at Spotswood Hotel, had prepared three rooms for Davis. Rooms 121 and 122 were the president's personal quarters, while room 83 served as a parlor. Hoeninger decorated the parlor with a coat of arms and a Confederate flag. No sooner had Davis arrived than the crowds began clamoring for a speech. The president acceded to their wishes, stepped to his window and addressed the crowd, estimated at thousands. Davis spoke for ten minutes, thanking the crowd for their welcome and patriotism. After the cheers and applause died down, Davis retreated back inside the hotel for breakfast. He spent much of the day welcoming politicians and well-wishers.[39]

Spotswood Hotel would in time be "as thoroughly identified with Rebellion as the inn at Bethlehem with the gospel." Mary Chesnut considered the hotel "a miniature world." The multistoried structure was built around a

A History

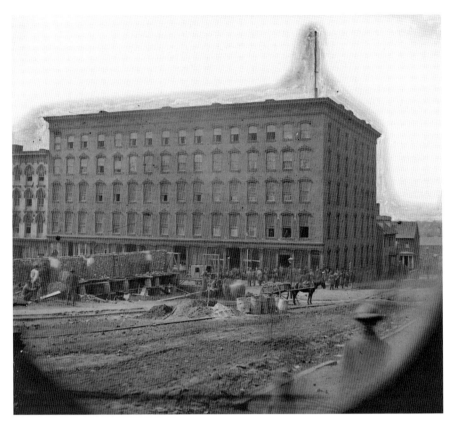

The Spotswood Hotel was the home of Jefferson Davis for several weeks after the transfer of the government from Montgomery to Richmond. The building burned in December 1870. *Library of Congress.*

central courtyard. The bottom floor contained shops. One witness recalled, "Over the hotel, and from the various windows of the guests, waved numerous Confederate flags." Besides Davis, the hotel accommodated politicians such as the Chesnuts and Wigfalls; Secretaries Walker, Memminger and Mallory; and other high-ranking officers. Other ranking officials chose to make their home at the Exchange Hotel, including Robert Toombs.[40]

Prior to leaving Montgomery, the Confederate Congress dispatched a Mr. Giles to Richmond to secure a suitable location for offices. Finding the recent Federal customshouse available, the building was leased. Constructed in 1858, the twenty-two-thousand-square-foot structure contained three floors, plus a basement. Up until Virginia's secession, the building housed a post office; offices for the customs collector, district attorney, Federal marshal,

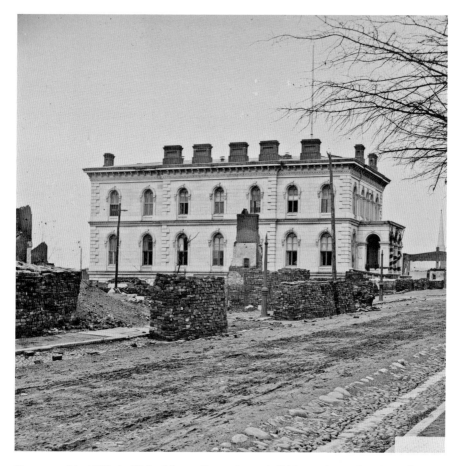

Constructed in 1858, the United States Customhouse in Richmond served as the main office building of the Confederate government. The building survived the fires of April 1865 that swept through the city and is currently the Lewis F. Powell United States Courthouse. It is not open to visitors. *Library of Congress.*

clerk of court and judge; along with a courtroom and various rooms for juries. The new headquarters for the Confederate government sat on Main, Bank and Eleventh Streets. War Department clerk John Jones wrote of arriving in Richmond a little after noon on May 31. After meeting with his family, he went to the customshouse and secured all of the rooms on the first floor for his department's offices. Jones's work created some discord. When Toombs arrived, he stated that "the 'war office' might do in any ordinary building; but the Treasury should appropriately occupy the custom-house, which was fire-proof." Jones was happy to report that the arrangement he had made in relationship to the offices "was not countermanded by the President."

Additional offices were located on the other two floors. Davis used the old federal judge's office as the executive office, while the adjoining Federal courtroom was converted into a cabinet meeting room and war planning room. The walls, according to a later history, were covered with large maps of both the new Confederacy and the surrounding border states.[41]

On June 10, the *Richmond Dispatch* reported that former tenants of the Mechanic's Institute were moving out of the building. The Confederate government leased that building as well. After some remodeling in which the four-story building, located on Ninth Street between Main and Franklin, was further divided into offices for the War Department, Navy Department and Justice Department, they took up occupancy on July 1. This building was also newer, having been completed in 1857. Yet one state officer considered it "an ungainly pile of bricks, formerly used as a library and lecture-rooms." Mallory's Navy Department, along with Benjamin's Department of Justice, occupied part of the second floor. Although visiting was discouraged, the government buildings were open to visitors from nine o'clock in the morning until three o'clock in the afternoon. Upon entering the building, a visitor announced his business to one of the department messengers before being admitted to whichever departmental office he sought.[42]

By June, the *Richmond Dispatch* was reporting that the Confederate Patent Office was opening in Goddin's Hall. Prior to the arrival of the Confederate government, Goddin's Hall was used by the Young Men's Christian Association as a place of prayer and a library. The YMCA had "yielded readily and cheerfully" to the new government. The patent office was under former United State patent examiner Rufus Rhodes. On August 1, 1861, the Confederacy's first patent was issued. It was to James Houten for a breech-loading gun. It appears that the postal department later used parts of this building, as did a branch of the auditor's office. Eventually, the Confederate government spread to other buildings in Richmond. The comptroller's office was in the Arlington House, while branches of the auditor's office were in both the Monumental Hotel and the Clifton House.[43]

"Upon every hill which now overlooks Richmond," Davis told the crowd in front of the Spotswood Hotel, "you have had, and will continue to have, camps containing soldiers from every State in the Confederacy." Many of those troops were sent to Camp Lee, at the fairgrounds outside town. These troops were pouring in from every state in the Southern Confederacy. The majority of new regiments arrived on the railroad and marched through the streets to one of the training camps. Local resident Catherine Hopley found the streets full of "soldiers singly, soldiers in pairs, in squads, in files. Drums and fifes and crowds

of soldiers, and nothing more." For the tens of thousands of soldiers pouring through the city, it was an eye-opening experience. For most, Richmond was the largest city they had ever visited. One North Carolina soldier wrote home, "[Richmond] is a big place…I saw the Stutute of Washington he was siting on a horse Jest looked like man drest in milatery close…the nigurs was drest finer than the white people [at home]." A chaplain from the same state recalled that as they went through Richmond, "the ladies cheered us by waving white handkerchiefs from every cottage, this with Southern flags waving at other places, with many bouquets thrown to our boys as we passed by."[44]

The population of Richmond swelled. While an exact number of new people is unknown, most historians estimate the population doubled,

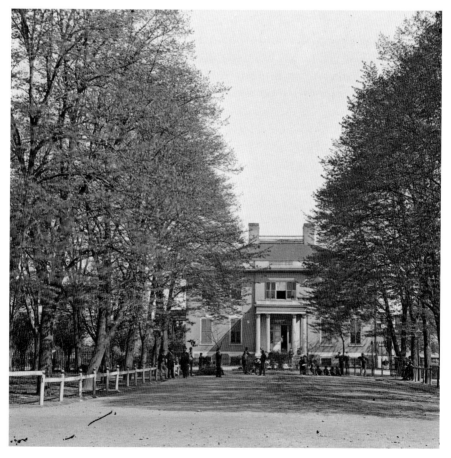

Upon arriving in Richmond, Jefferson Davis held his first public reception at the governor's residence. The mansion sits adjacent to the Virginia state capitol. *Library of Congress*.

from near 40,000 prewar to 100,000 by 1863. This influx of so many led to considerable disorder at times. A group of Zouaves ate at a local restaurant and charged the meal to the Confederate government. Liquor was cheap, and fights, stabbings and even shootings were frequent. Many offenders found themselves in the mayor's court to answer charges. The offenders were often guilty of "selling ardent spirits without a license" or of keeping a barroom open after hours. The Richmond City Council took steps attempting to maintain control. Ordinances were enacted that closed barrooms at 10:00 p.m. and all day on Sundays. In July 1861, the *Richmond Dispatch* ran an article reminding merchants of the ordinances, adding that the "profits must be extensive to pay the fine…and leave a margin for profit." The hubbub was obviously enough to drive some locals indoors. The newspaper commented that same month that the deployment of soldiers elsewhere had cleared up some of the streets and meant those of the fairer sex were once again "flitting like butterflies along our thoroughfares."[45]

As not all ladies were genteel butterflies, prostitution, like drinking, flourished in the city. One reporter wrote not long after the war that one of the cars coming out of Montgomery "had…some 'fair ones,' whom a good brother would not introduce to his sister." Richmond's upper-class harlots were situated along Franklin Avenue and Locust Alley, at the Ballard and Exchange Hotels and above the numerous gambling establishments. The *Richmond Examiner* reported in May 1862 that women of ill repute "have been disporting themselves extensively on the sidewalks, and in hacks and open carriages…[with] smirks and smiles, winks and…remarks not of a choice kind in a loud voice." There were two other areas largely associated with alcoholic whores and illegal liquor sales in Richmond. To the west along Broad Street was the suburb of Screamerville, and a mile east of downtown, along Main and Cary Streets, was yet another squalid cesspool that catered to the lowest classes of Richmond's society. Numerous people were hauled before the mayor's court, including James Moore, for "keeping an ill-governed and disorderly house." His neighbors came to his defense, stating Moore was a peaceable man, "but his wife was guilty of the offence laid to his charge." These were charges repeated over and over again through the war.[46]

Along with the office seekers, politicians, family members, government employees, soldiers and prostitutes came the refugees. As the Federals advanced into Confederate territory, citizens with pro-Southern leaning often left their homes for more secure locations. John McGuire, an Episcopalian minister, along with his wife, Judith, left his home in Alexandria

The Capitals of the Confederacy

in May 1861 as the Federals crossed over the Potomac River and captured the town. After sojourning with family and friends in Northern Virginia for a time, Reverend McGuire was able to secure employment with the post office department in Richmond. Judith noted in her diary the plight that refugees had in securing lodging. "The city is overrun with members of Congress, Government officers, office-seekers, and strangers generally," she wrote. "Main Street is as crowded as Broadway, New York." McGuire spent several days walking the streets of Richmond. A friend had better luck, considering herself "nicely fixed…in an uncarpeted room, and so poorly furnished, that, besides her trunk, she has only her wash-stand drawer in which to deposit her goods and chattels." It took McGuire over a week to find a small room on Grace Street. War Department clerk Jones decided quickly that he could not support his family on his government salary and chose, for a while, to send his family to the home of a cousin in New Bern, North Carolina.[47]

Varina Davis and the rest of the president's family arrived in Richmond on June 1, escorted by a cheering crowd from the train station to Spotswood Hotel. That evening, a crowd estimated at three thousand serenaded the first family, with Davis later addressing assembled well-wishers. Frequently, Varina took a carriage out to watch the president review the troops. For a time, Davis did this almost every evening and on special days. In July, the *Richmond Enquirer* reported that President Davis was at Camp Lee, presenting a First National flag to a company from Maryland.[48]

Thoughts were always focused on the military situation. On May 24, a day after delegates in Montgomery chose to move the capital to Richmond, Federal soldiers crossed the Potomac River and captured Alexandria, Virginia. The Union had invaded the Old Dominion. Newport News was in Union control by the time Davis arrived in Richmond, and Federal naval vessels shelled Confederate batteries at Aquia Creek, just northeast of Fredericksburg, on May 31. That same day, P.G.T. Beauregard, the hero of Fort Sumter, arrived and was thronged by a cheering crowd as a hack took him to the Exchange Hotel, after a stop to see Davis at Spotswood. Immediately, Beauregard was placed in command of all Confederate forces in Northern Virginia. A minor skirmish was fought near Big Bethel Church in mid-June, a resounding Confederate victory. Thirteen Federal soldiers captured during the battle were brought to Richmond and initially imprisoned in the basement of the customshouse, "where many of our citizens evinced some degree of curiosity to get a peep at the captured Yankees," noted one newspaper. The prisoners were taken to the city jail, back to the customshouse and finally to the Henrico County Jail. Prisoners had obviously not been much of a factor

in the new Confederate government's plans. It was not until the end of June that a tobacco factory belonging to George D. Hardwood was leased by the Confederate government for $150 a month and converted into a prison.[49]

Soldiers continued to pass through Richmond, en route to Beauregard's command stationed around Manassas. The Federal army under Irvin McDowell was not far away, near Alexandria. With thirty-five thousand men, McDowell, under pressure from his superiors, set out on July 16. Contact was first made two days later at Blackburn's Ford. On July 21, the first battle of Manassas, fought along Bull Run, resulted in a Confederate victory. Davis headed toward Manassas with his nephew and aide-de-camp Joseph Davis that very morning on a special train, arriving on the battlefield later that day. Back in Richmond, everyone was waiting for news. At the War Department, the entire cabinet had crammed into the secretary's office, while Walker was seen pacing the floor. Eventually, Benjamin headed to the Spotswood Hotel, where he learned from Varina Davis of a "glorious victory." Benjamin traveled back to Mechanic's Hall to inform the others. "The city seemed

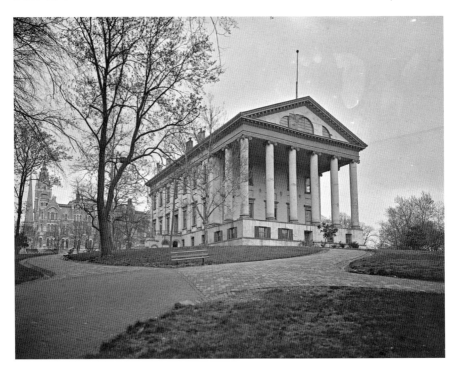

Designed by Thomas Jefferson and constructed in 1788, the Virginia state capitol not only served as the state capitol but also as home to both houses of the Confederate Congress. *Library of Congress*.

lifted up," Jones wrote in his diary, "and every one appeared to walk on air." Another diarist chronicled, "Men were beside themselves with joy and pride-drunk with glory. By night the city blazed with illuminations, even the most humble home setting up its beacon-lights."[50]

Capital Square was abuzz the day after the battle. Mayor Mayo called for a mass meeting of Richmond residents in order to address the serious issue of caring for large numbers of casualties. Manassas produced more than 1,500 wounded Confederates and over 1,124 wounded Federals. The masses gathered in Richmond appointed three committees: one to repair to Manassas to care for the wounded, another to prepare the city for their arrival and one to solicit donations to help pay for needed supplies. There were twenty-nine citizens appointed to go to Manassas, including the mayor and several local doctors. They left on the next train the following morning. Following the meeting, the hospital committee met in the office under the Insurance Company of Virginia. "Persons wishing to take wounded soldiers," read the newspaper, "can report at the above office at the Sergeant's office, City Hall." There were four hospitals in Richmond prior to the war. As the number of recruits in Richmond grew, the cases of sickness likewise multiplied. One former drill room on Church Hill was serving as a hospital in early June 1861 for members of a Tennessee regiment. Also pressed into service was the Sons of Temperance Lodge on Twenty-sixth and M Streets.[51]

Wounded soldiers began to trickle in on the evening of July 23 and were quickly sent to homes. That evening, around 20 or 30 arrived. Another 200 were brought in the next morning. Instead of bringing them all to the depot, the train stopped in various neighborhoods and dispatched its suffering cargo to various places. Others were transferred and shipped via rail to Staunton. Two more trains arrived that evening, bearing 175 wounded and sick.[52]

Also arriving were those who were beyond need of medical care. The body of Colonel Charles F. Fisher arrived on July 23 and was escorted by the Fourth North Carolina State Troops from the Virginia Central Railroad depot through the streets of Richmond to the Richmond and Petersburg Railroad depot. "It has hardly been a week since the lamented officer passed the streets of our city at the head of his regiment," bemoaned one newspaper. Colonel Francis Bartow's body arrived on the evening train. Mary Chesnut recalled that it fell to Varina Davis to tell Mrs. Bartow of her husband's death. Mrs. Bartow was lying on her bed when Mrs. Davis entered and saw the pale face of the message bearer. "'Is it bad news for me?' Mrs. Davis did not speak. 'Is he killed?'" The silence answered Mrs. Bartow's inquiry, but she already knew the answer. Bartow's body lay in state in the capitol before

being taken to Georgia. Mary Chesnut continued her diary, describing a Richmond military funeral. The "march came wailing up" the street. "The empty saddle—and the war horse—we saw and heard it all. And now it seems we are never out of the sound of the Dead March." Of course, the pomp surrounding the burial was often reserved for those of high rank. The common soldier might get an escort and a few words by a local minister or chaplain, at least early in the war.[53]

Jefferson Davis arrived on the July 23 evening train, the same train that brought a few of the wounded, along with the bodies of Colonel Bartow and others. Since the wounded were expected, a guard was stationed around the depot, keeping the crowds of people at a distance. When it became known that Davis was on the train, "a rush was made in search of this distinguished statesman and chieftain, and a thousand shouts rent the air with wild huzzas as his well-known face and figure were discovered." Davis spoke, regaling the crowd with what had taken place on the battlefield, the number of cannons captured, the numerous wagons and other food "to feed an army of fifty thousand men for twelve months." Davis made his way back to his rooms at the Spotswood, where, that evening, the masses again called for him to speak about their glorious victory.[54]

"Our prisons are filled with Yankees," Jones wrote in his diary. Confederate armies had won the field, capturing many who were unable to get away, along with many of the wounded. It was estimated that one thousand Federal soldiers fell into Confederate hands. The Richmond *Examiner* reported on July 25 that two cars of wounded Federals had arrived, a great many of them belonging to Ellsworth's Fire Zouaves. "They were all wounded in the most horrible manner," the paper reported, "and as their wounds had received no attention, they were in a truly pitiable condition." Many of the Federals were taken to a warehouse and ship chandlery that belonged to the Libby family. It became known as Libby Prison. Reverend J.L. Burrows recalled after the war that little had been done to prepare for large numbers of prisoners and that no one had any experience in the matter. The prisoners "were therefore necessarily subjected to many inconveniences and privations…They slept upon the floor on their blankets, if they had been thoughtful enough to bring any, and ate their rations from their fingers, or spread them out in boxes or barrel-heads."[55]

Among the prisoners was Congressman Alfred Ely of New York. Ely had ridden out to watch the battle and was captured in the rout that followed the Federal defeat. He recalled in his journal of the trip from the battlefield to Richmond via the train and, upon his arrival, of being taken to Liggon's

Libby Prison was a three-story warehouse that housed Captain Luther Libby and Son's ship chandlery and grocery business prior to the war. The Confederate government used it as a prison for Union officers. *Library of Congress.*

tobacco factory. The upper two floors of the warehouse were already crammed with prisoners, "lying down and standing up, and so closely huddled were they that there was scarcely room left for the officers to lie down." Ely estimated that there were six hundred prisoners being held in the building and that they were fed bread, beef and coffee. Prisoners were not allowed to get close to the windows. If they did, they were fired upon. Despite numerous attempts by many politicians who had served with Ely prior to the war, the congressman was not released until December 1861.[56]

Federal prisoners and Confederate wounded were minor concerns of the Confederate political leaders meeting in Richmond. Despite being in the minority, Davis believed the war would last a long time. Few in

the Confederacy could grasp the enormity of money required to fight a prolonged conflict. Most believed that cotton was the key to the problem, yet the 1860 crop was gone to market, and the 1861 crop would not be ready until the fall. Even then, there was a lack of ships and a tightening Federal blockade. The Confederate government could either tax its people, borrow from another government or rely on fiat money, a monetary system declared legal by the government. While the government preferred to borrow, the need outweighed the resources coming into the coffers. The fledgling government was forced to rely on fiat money, and the financial foundation of the Confederate States deteriorated as the war progressed. Also on the mind of Davis was the defense of his country's borders. He had thousands of miles of borders to protect and limited resources to use. The Confederate government was struggling to arm and equip the thousands of men who rallied around the new nation's flag.

Much of the debate regarding the financial straits and the armament of the Confederacy took place at Virginia's state capitol. The 1788 building, which sat on a hill overlooking much of Richmond, was "picturesque from the river," recalled De Leon, "but dirty on close inspection. It is a plain, quadrangular construction, with Grecian pediment and columns on its south front and broad flights of steps leading to its side porticoes…in the small rotunda…stood Houdon's celebrated statue of Washington." Upon arrival, the Provisional Confederate Congress was called into session on July 20, 1861, and met in the house chamber. The room was described as being "pleasant and airy, about twelve-by-twenty-five yards in size, with the speaker's chair in the center opposite the room's entrance. The walls, however, were bad and the chair uncushioned, and the desk 'slashed with pocket-knives.'" The Confederate House continued to meet in this chamber after the Congress became bicameral in 1862. When the Virginia Senate was not in session, the Confederate Senate used its chambers. When the two bodies were in session at the same time, the Confederate Senate used two rooms on the third floor.[57]

One of the many acts of the Confederate Congress was to provide a home for the Davis family. The City of Richmond purchased a home on East Clay Street, just two blocks from the capitol. Originally built in 1818 for John Brockenbrough, president of the Bank of Virginia prior to the Confederacy's formation, the home was owned by Lewis Dadney Crenshaw, who had remodeled and added a third story. The City of Richmond purchased the graceful Federal-style residence and wanted to give it to Davis, but the offer was declined. Instead, the Confederate government

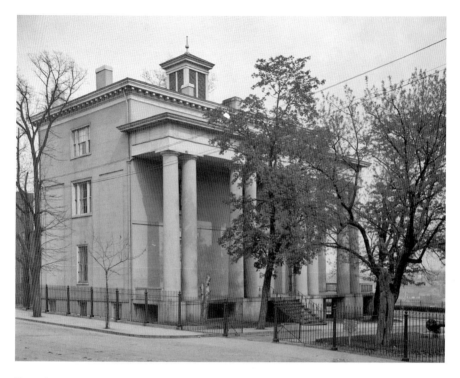

From August 1861 to April 1865, the Brockenbrough home served as the executive mansion for the Confederate States of America. The home has been restored and, for many decades, has been a museum. *Library of Congress.*

rented the structure for use as the executive mansion. Davis moved in on August 1, 1861. Varina wrote, "One felt here the pleasant sense of being in the home of a cultivated, liberal, fine gentleman." She went on to describe the house as being "very large, but the rooms are comparatively few, as some of them are over forty feet square. The ceilings are high, the windows wide, and the well-staircases turn in easy curves toward the airy rooms above." Public rooms, such as the state dining room, a parlor and formal drawing room, were found upon entering the first floor through an oval entrance hall. On the second floor were offices for Davis and his secretary, along with a master bedroom and nursery. The top floor was for guests and aides, while the basement contained a small dining room, warming kitchen, pantry with additional storage and rooms for servants. There were marble mantels with Greek carvings and a terraced garden in the rear, planted with apple, pear and cherry trees. Also out back were a two-story kitchen, a stable, a carriage house and slave quarters. While the house is often referred

to as the White House of the Confederacy, its color was gray, and many called it the "Grey House."[58]

Virginia's secession and the arrival of the Confederate government drastically altered the landscape of Richmond. Jones in the War Department complained in November that the price of dry goods had increased over 100 percent in just a few months and that rent of houses and rooms was on the same pace. The Union blockade reduced the number of vessels arriving at the docks in Richmond by sixty-eight and canal tolls were down by almost 47 percent over the previous year. Plus numerous tobacco factories were converted to house hospitals and prisoners, stifling the tobacco trade. Many complained of the reckless manner in which teamsters drove their wagons down the street, while the street superintendent allowed the gutters to back up. On the positive side, there were now more hotels, boardinghouses, restaurants, bawdy houses and bars, all trying to accommodate the swelling population.[59]

Richmond was experiencing a construction boom. Some buildings, like Mechanic's Hall, were being converted into government office space. Other projects were new construction. In October 1861, Confederate surgeon general Samuel P. Moore acquired an approximately forty-acre site, located on Chimborazo Hill and originally intended to be military barracks, for a new hospital. Tobacco factory workers were brought in to build 150 single-story buildings, each measuring one hundred by thirty feet. Also constructed were soup houses, a bakery, brewery and Russian bathhouse, along with five icehouses. A nearby farm had a large herd of goats, and convalescents worked in the hospital's garden. The hospital also had its own boat that sailed up the James River all the way to Lexington in search of fresh food for the patients. There were over fifteen hospitals in Richmond by the end of 1861.[60]

Southerners went to the polls on Wednesday, November 6, to elect their first permanent president, vice-president and congressional leaders. No one ran opposed to Davis and Stephens, and they were elected for a six-year term. Members of the first regular Congress were also elected. While there was only one political party, there were various factions within that party. Davis's inauguration took place on Saturday, February 22, which is also the birthday of George Washington. On a rainy and dreary morning, Vice-President Stephens, the Confederate cabinet, Congress and the Virginia General Assembly gathered inside the Virginia Statehouse. The building was crowded with guests and observers. When everything was ready, Davis was escorted outside onto a platform at the base of the Washington monument. The crowd was estimated at two thousand, but the dull noise of the rain

The Capitals of the Confederacy

Chimborazo Hospital, in the rows of buildings along the horizon, was one of the largest hospital complexes constructed during the war. Tens of thousands of sick and wounded soldiers passed through the various wards. *Library of Congress.*

falling on the numerous umbrellas masked Davis's remarks. Constance Cary recalled viewing Davis's inauguration from the window of the library in the capitol building. "When the poor wet bishop and the President-elect came upon the stand, there was an immediate, portentous hush in the crowd. One heard nothing but the patter of the winter rain. The brief ceremony over, when President Davis kissed the book, accepting, under God, the great trust of our young and struggling nation, a great shout went up and we distinctly heard cries of 'God bless our President!'" That evening, a reception was held in the executive mansion.[61]

While Davis encouraged his countrymen, the overall picture was already turning bleak for the Confederacy. Early victories at Manassas, Wilson's Creek and Ball's Bluff had given way to losses at Mill Springs, Fort Donelson and along the Outer Banks. The Confederacy was struggling to turn its limited manufacturing infrastructure from peacetime to wartime production. An added difficulty was that the enlistment terms of the men who volunteered to serve one year were set to expire in the spring. In response to sluggish reenlistments and new volunteers, Davis proposed a Conscription Act in February, which became law in April. The law required all white

males between the ages of eighteen and thirty-five, unless exempt, to serve in the Confederate army. It was an extremely unpopular piece of legislation. The Confederate cabinet had also been shaken. While Reagan stayed as postmaster general, Memminger as secretary of the treasury and Mallory as secretary of the navy, the secretaries of state and war had changed several times. Toombs resigned the State Department in July 1861 to be replaced by Robert M.T. Hunter. Hunter served until February 18, 1862, when he was replaced by William M. Browne, who served for a month. On March 18, 1862, Browne was replaced by Judah P. Benjamin. In the War Department, Walker was replaced by Benjamin on September 17, 1861. When he moved to the State Department, George W. Randolph became secretary of war.

Not long after the first signs of spring burst from nature, the war came to Richmond. On March 7, the main Confederate army in Virginia left the entrenchments around Manassas and moved south to a defensive line on the Rappahannock River. The following day, the CSS *Virginia*, whose iron plating was manufactured by the Tredegar Iron Works in Richmond, steamed out from Norfolk and gave battle to the United States Navy. Several vessels were sunk or damaged. On March 9, the *Virginia* and USS *Monitor* battled in the same area, and the brief naval superiority the Confederate navy demonstrated with the *Virginia* was neutralized. This was followed by the lead elements of a massive Federal army landing at Fortress Monroe, not far from Richmond. The great campaign to take the Confederate capital had begun. Quick thinking by a Confederate officer bogged down the Federal advance at Yorktown, giving Confederates time to transfer from the Rappahannock line to a nearby defensive line. A call went out through local churches on April 1, announcing that the Confederate soldiers were moving through Richmond's streets, and they had not eaten in twenty-four hours. Roads were soon jammed with local citizens bearing baskets of food. The tramp of soldiers continued for days.

After holding the Federals at bay for a month on the lower peninsula, Confederate commander Joseph E. Johnston retreated back toward Richmond on May 3. This movement also caused the loss of the naval base at Norfolk and the destruction of the CSS *Virginia*. When Johnston's retrograde movement ended, the Federal army was just five miles from Richmond. Some Federals commented that they were able to see the church spires within the city. With rumors floating around that Richmond would be blown up or set on fire, many fled the capital city. The Confederate Congress adjourned, and Varina Davis and her children left on May 10 for Raleigh. Papers from the War Department were boxed up and could be seen sitting

next to office doors, marked "Columbia, South Carolina." Davis even sent away his books and his pistols from the Mexican War. "Much anxiety is felt for the fate of the city. Is there no turning point in this long lane of downward progress?" Jones lamented in his diary. Governor Letcher called for a meeting at city hall to organize local companies for local defense. The city council was meeting daily, and local women were preparing the hospitals for the upcoming contest.[62]

Johnston attacked a portion of the Federal army at Seven Pines, just east of Richmond, on May 31. Confederate attacks were initially successful in driving the Federals back, but reinforcements stabilized the Federal lines, and after further attacks on June 1, the outcome of the battle was inconclusive. Local citizens lined the hills to the east of town, trying to interpret the sounds of battle. In the midst of first day of fighting, Johnston was wounded. Davis replaced his stricken field commander with Robert E. Lee. The battle produced almost five thousand Confederate wounded, who overwhelmed Richmond's expanded Confederate hospital system. For days, a line of ambulances, wagons and ox carts hauled the wounded and killed to different hospitals or cemeteries in the city. Several buildings were converted into new hospitals, including the Baptist Female Institute on Tenth Street between Clay and Marshall; the dry goods store of Kent, Payne and Company on Main Street between Eleventh and Twelfth Streets; the warehouse of Bacon and Baskerville on Cary Street between Twelfth and Thirteenth; and Seabrook's Tobacco Warehouse on Grace Street. The latter became a receiving and distribution hospital and was located close to the Virginia Central Railroad depot. In less frantic times, arriving patients were "subjected to a steaming process and the administration of a shower bath, after which a dram, a good supper, and a clean bed is given them… They awaken the next day refreshed and invigorated for transfer to another hospital." After his wounding, Johnston recuperated at the Robertson Hospital, the former home of a local judge. This particular hospital was under the control of Captain Sally Tompkins, the only woman commissioned by the Confederate government. Tompkins provided better care than most other facilities, as evidenced by a death rate of only 5.5 percent of her patients. Among the many wounded during the battle was Juliet O. Hopkins, the wife of an Alabama judge who personally opened three hospitals in Richmond for Alabama soldiers. She was helping load wounded on the battlefield when she was struck twice in the hip, leaving her with a limp for the rest of her life.[63]

Lee took command of what he termed the Army of Northern Virginia, whose goal was to drive the enemy away from the gates of Richmond.

Earthworks were strengthened or constructed around Richmond. "What a change!" Jones chronicled. "No one now dreams of the loss of the capital." After three weeks of strengthening works and deploying troops, which included Stonewall Jackson's command from the Shenandoah Valley, Lee launched a series of attacks on the right flank of the Federal forces, now known as the Seven Days Battles; Lee pushed the Federals back down the peninsula and away from Richmond. Those eight battles, fought between June 26 and July 1, 1862, produced over 20,000 Confederate killed, wounded and captured, along with 15,855 Federal killed, wounded and captured. Over 15,000 Confederate wounded, along with thousands of wounded and captured Federals, overwhelmed Richmond. "Every family received the bodies of the wounded or dead of their friends, and every house was a house of mourning or private hospital," wrote Sallie Putnam. "Death held a carnival in our city." Chimborazo, along with Winder Hospital, which was Richmond's largest hospital on the western part of the city, and more than a score more general hospitals were filled beyond capacity. Even the basement of the Spotswood Hotel was turned into a temporary hospital.[64]

Due to the numbers of wounded who later died, the dead were piling up faster than the burial crews could inter them. Soldiers who died in the eastern portion of the city's hospitals were buried in Hollywood Cemetery, while those who died in the western section were interred at Oakwood Cemetery. By the end of April 1862, 739 soldiers had been buried in the soldiers' section at Hollywood, not to mention in plots already owned by families at Hollywood, Oakwood and Shockoe Hill. By the time of the Seven Days campaign, the soldiers' section at Hollywood was already full. At Oakwood, a visitor reported seeing thirty-nine coffins awaiting burial. "The influence of heat had caused the bodies of some to swell and burst the coffins," one newspaper reported, "and the atmosphere for a considerable distance around was impregnated with the stench of putrefaction." The cemetery keeper complained that he only had six gravediggers and could not keep up. In July, the city pursued the Confederate government to purchase additional land at Hollywood in an attempt to stay abreast of the demand for space.[65]

By mid-July, the focus of the war was moving north of Richmond. A new Federal army was hovering in the Manassas area, and Lee began shifting troops from the Richmond front to meet this threat. Nevertheless, the war was never far away. Thousands of Confederates remained in area hospitals, and cemetery officials still struggled under the load of dead soldiers. There were so many Federal prisoners in mid-June that the government moved enlisted personnel to Belle Isle, located in the James River and connected

The various Confederate hospitals utilized existing cemeteries in Richmond. The graves of soldiers, as shown here in Oakwood Cemetery in 1865, were often marked with wooden headboards. *Library of Congress.*

by a footbridge to Richmond. The prison site itself was about four acres, surrounded on at least one side by earthworks manned with soldiers and artillery. There were no buildings for the prisoners, just tents, and the summertime suffering was intense. By mid-July, there were five thousand prisoners on Belle Isle, with another three thousand in Richmond proper. Two months later, Belle Isle was emptied. The captives were either paroled or transferred elsewhere.[66]

There were frequent complaints by the prisoners regarding the rations they were issued. William Goss, captured at Savage Station, was held on Belle Isle. He wrote that the prison commissary was just outside the deadline and that when rations were issued, the noncommissioned officers would report to the commissary and carry the issued rations in on blankets infested

Belle Isle, in the James River, was used as a holding facility for Federal prisoners of war. These prisoners were transferred to other facilities across the South. *Library of Congress.*

with vermin. Those rations consisted of half a loaf of bread per man, with beans. The beans were "about twenty percent maggots,—owing to scarcity of salt; thirty per cent. beans, and the remainder in water." If a prisoner had money, he could purchase molasses for $1.00 per pint, sugar for $1.50 per pound and onions for $0.25 apiece. "Butter and milk could rarely be had at any price," Goss wrote.[67]

Goss would have been surprised to find that food prices and availability were little better off Belle Isle. In early April, Brigadier General John H. Winder, in charge of the Department of Henrico, attempted to cap prices of foodstuffs. The plan backfired. Farmers simply stopped bringing in supplies, and by the end of the month, Winder relented and lifted the cap. He tried it again on July 12, capping the price of corn, followed by livestock fodder and bedding. Once again, farmers quit bringing in these items, and Winder was forced to back down. Jones recorded in his diary in October that sugar sold for eighty cents per pound, a quart of milk for twenty-five cents, loaves of bread for twenty cents each and one pound of sausage meat for thirty-seven and a half cents. He was able to get cornmeal, roasted and used as a coffee

substitute, for five or six cents per pound, while the real thing, when it could be found, was $2.50 per pound.[68]

Jones, through the pages of his diary, was chronicling the hardships he and his family experienced during the war. While Jones had a job as a clerk in the War Department that provided a good wage, he struggled to make ends meet for his family. He was not the only one. Vice-President Alexander Stephens, on one of his few visits to the Confederate capital, noted that it cost him $900 a month for a room and another $900 a month for fuel and extras. "It will not take long to consume my salary," he wrote to his brother Linton back in Georgia. Stephens was staying with Louisiana senator Thomas J. Semmes. Also boarding with Semmes was Augustus Garland of Arkansas and Edward Sparrow of Louisiana.[69]

One often-overlooked story is that of Richmond's poor during the war years. The war hit the laboring and poorer classes of people hard. "We saw, Yesterday," wrote the *Richmond Dispatch* in April 1862, "an aged woman approach a stall and ask the price of a diminutive piece of bony beef. The price was mentioned. The poor woman looked at the beef and then at her little stock of money—paused a moment and, sighing deeply, moved away and out of the market without a particle of any sort of food in her little basket." Many were obviously destitute and discouraged. In one case, thanks to lack of pay for six months, the families of several members of an artillery company assigned to garrison duty were forced to seek shelter in Richmond's poorhouse. Judith McGuire told the story of a friend who, while out walking one day, came across a "wretchedly dressed woman, of miserable appearance," looking for the YMCA. The organization had set up a collection and distribution point for helping the needy in Richmond. Yet the building was closed. McGuire's friend took the poor lady to her own home and fed her, telling her to return. The lady had lived in Fredericksburg, and her husband was killed at the Second Battle of Manassas. She fled Fredericksburg with her three children and found lodging outside Richmond, which was cheaper, but could not find enough work to survive. Since she lived outside the city limits, she was not eligible for assistance provided by the City of Richmond.[70]

Others resorted to differing levels of crime. In one instance, two fifteen-year-old boys, one white and one black, "of squalid appearance," stole "shoes, butter, beef, socks and other things out of the carpet bag of two North Carolina soldiers." In another case, Elizabeth M. Jeter was hauled before the court. The paper reported that she had "no husband, but a child at the breast" and was facing charges of keeping a disorderly house "and

generally reputed place of prostitution." Jeter claimed she supported herself by taking in sewing, but witnesses testified to seeing her begging. In the end, the mayor ordered her back to Petersburg. In another case, Mrs. Martha Cardonia was examined before the mayor and two other justices. Cardonia stated that "she wanted to kill her children rather than see [them] famish; that she had once loved her children, but now that she had become too poor to provide for them, that she would prefer to see them dead." The mayor sent her on to the jail to be observed. In an attempt to help, in April an ordinance was adopted to try and help with the poor. There were overseers set up, responsible for the distribution of provisions and fuel. Those with a ticket could visit a free market once a week for food. As usual, there were more poor than resources to go around.[71]

If the high prices and challenging living conditions were not enough, in the winter of 1862–63, smallpox struck the city. Once again, the poorer populations bore the brunt. The city council offered free vaccinations to those who could not afford them, while quarantining those afflicted. In two months, seven doctors had vaccinated more than 700 people. Part of Howard's Grove Hospital was used for the black population. From December 12 to December 19, there were 250 people admitted to various hospitals for smallpox, with 110 deaths. The Richmond *Examiner* reported on December 29 that smallpox was on the increase. "The city hospital is filled to suffocation with its victims, while the Confederate Government has a large hospital in the city and another at Howard's Grove, which are also full." By the end of January 1864, smallpox claimed 1,020 people in the Confederate capital.[72]

Possibly the most outward sign of the discontent experienced by the lower classes was manifested in early April 1863. Many people in Richmond were starving. There had been twenty-seven recorded snowfalls that previous winter. A crowd of women gathered at the Baptist church on Oregon Hill early on the morning of the second. They soon agreed to meet at Capitol Square. A delegation of these women proceeded to the governor's home, demanding something to eat. The governor asked them to come by his office a little later and then returned to his breakfast. In the square, one officer's wife sat on a bench observing the multitudes. A young lady came and sat beside her. When asked about the possible celebration, the young, neatly dressed but emaciated girl replied: "'There is,' said the girl, solemnly; 'we celebrate our right to live. We are starving. As soon as enough of us get together we are going to the bakeries and each of us will take a loaf of bread. That is little enough for the government to give us after it has

taken all of our men." The crowd of a thousand or more left the square and proceeded down Ninth Street to Main, passing the War Department, where Jones saw them and asked about their mission. Mary Jackson, "a tall, daring, Amazonian-looking woman" with a feather in her hat, and Minerva

Northern newspapers were quick to jump on the story of the Richmond bread riots. *Frank Leslie's Illustrated Newspaper* ran this sensationalized illustration in May 1863, just a month after the event took place.

Meredith, who carried a pistol, led the group. They commandeered carts as they progressed, and eventually the mob broke into the government commissary and the local shops. Others arrived, and many broke into additional stores, taking not only foodstuffs but clothes as well. Firemen attempted to break up the crowd with water, and soon a company of armory workers arrived. Governor Letcher came onto the scene, along with Mayor Mayo, who read the Riot Act. The crowd was given five minutes to disband before being fired upon. The looting stopped, but the crowd went nowhere. Jefferson Davis arrived and stepped up onto an overturned wagon. Davis implored the crowd to go home, that disorder would discourage farmers from bringing food to the city. He went as far as to take the money out of his pocket and fling it into the crowd. Finally, Davis told the mob that they had five minutes to disperse, "Otherwise you will be fired upon."[73]

Slowly, the crowd broke up. Assistant Adjutant General John Withers begged the Richmond newspapers not to report the incident. They waited a day. But by April 7, the news was broadcast from the pages of the *New York Times*. At least forty-seven were arrested and hauled before the mayor's court. Many were women, but there were men arrested as well, including Dr. Thomas Palmer of the Florida brigade. It took days for the mayor to work his way through the cases. In response, Davis published an address to the people across the South, imploring them to forgo planting the cash crops of tobacco and cotton, instead focusing on foodstuffs for people and animals.[74]

After defeating Federal forces at Cedar Mountain and once again at Manassas, Lee took his army north, capturing the Federal garrison at Harpers Ferry but losing at South Mountain. The Battle of Sharpsburg, along Antietam Creek, was fought in September 1862, with an indecisive outcome. Lee was able to hold Federal troops back at Shepherdstown as he retreated across the Potomac River and into Virginia. Yet another Federal force attempted to get between Lee and Richmond in December 1862 at Fredericksburg, and once again, Lee was able to stymie the Federal attack. For the winter of 1862–63, Richmond remained safe.

Campaigning in Virginia began in May 1863, with the Battle of Chancellorsville fought to the west of Fredericksburg. Chancellorsville produced 7,100 wounded Confederates, along with numerous dead. No one was more lamented than the gallant Stonewall Jackson, mortally wounded by his own men. Jackson lingered until May 10, and his remains reached the capital on May 11. Businesses were closed, and flags flew at half-staff. Richmond had witnessed other funerals, but nothing compared to Jackson's. The train arrived a little after 4:00 p.m. "At the head of Broad

Street the speed of the train was slackened and it moved slowly down the street through the lines of citizens who stood in wonderful silence and with uncovered heads, to the depot at the corner of Broad and Eighth streets," noted a bystander. "The sad tolling of the bells…and the dull thud of the minute guns alone broke the stillness." It seemed that all of Richmond had turned out for the event. The crowd extended for an estimated two miles and was the largest ever assembled. Jackson's remains were taken from the train to the governor's mansion, where he was embalmed and a life mask was made. It was near midnight before the crowds were turned away. On the next day, Jackson was taken to the capitol to lie in state. Among the generals walking beside the hearse were James Longstreet, Richard S. Ewell, George Pickett, James Kemper and Richard Garnett. In a carriage following were Jackson's widow, Anna; his daughter, Julia; and Jefferson Davis. At noon, the casket was placed in the Confederate House of Representatives, where 20,000 people filed past. Early on May 13, after a brief service at the governor's mansion, Jackson's remains were taken to the train station and began their journey to Lexington, Virginia, the general's final resting place.[75]

Following the smashing Confederate victory at Chancellorsville, Lee chose to take his army north once again. On the first three days of July 1863, the Army of Northern Virginia fought in and around the town of Gettysburg, Pennsylvania. The Confederate defeat produced over eighteen thousand Confederate wounded. To help, the Richmond Ambulance Corps set out toward the retreating army. Formed a year earlier, the company's ambulances and their drivers reached Williamsport, Maryland, but found that many of the wounded had already been shipped to other points. One clerk reported that the slightly wounded from the battle began arriving in Richmond on July 13.[76]

Richmond had occupied the position of capital of the Confederacy for a little over two years. Confederate government operations occupied many buildings in the city, and thousands of government employees now called Richmond home. The population as a whole had more than doubled. Richmond was host to both the largest hospital in the Confederacy and a prison for captured Federals. Everyone suffered to some extent. Inflation caused near starvations and even led to at least one riot. Yet locals persevered, turning out in one of the largest displays of Confederate patriotism when the remains of Jackson were brought to the city in May 1863. Sadly for many, the next two years would be worse.

Chapter 3

Richmond, Virginia

July 1863 to April 2, 1865

While Lee battled the Federals at Gettysburg, Richmond itself was more focused on the twenty-five thousand Federals at Williamsburg and five thousand at White House on the Pamunkey River. The militia was called out to reinforce Confederate soldiers in the area. Many of the clerks in various departments, along with laborers in various wartime industries, had already been organized into companies and battalions. Richmond businesses closed, as did the Confederate treasury, post office and ordnance shops. "When the wild notes of the alarm bell sent their frequent peals over Richmond, and warned of an approaching raid—armorer, butcher and clerk threw down hammer and knife and pen, and seized their muskets to hasten to the rendezvous." Federal cavalry raided the Virginia Central Railroad Bridge over the South Anna River on June 26. On July 1, Federals at White House Landing were ordered to advance toward the same bridges to the north of Richmond. On July 2, the Richmond militia, along with the "Departmental Guard," was posted on Darbytow Road, and that evening, D.H. Hill drove back a Federal advance at Bottoms Bridge over the Chickahominy. At least the Department Guard was redeployed the evening of July 3, marching some sixteen miles from its original position to the Meadow Bridge over the Chickahominy River. By July 6, the crisis had passed, and the militia and army of clerks returned to their occupations in the city.[77]

News trickled into Richmond regarding Lee's march north and actions in Mississippi. At first, Lee had routed the enemy in Pennsylvania, and Confederate forces had come up in the rear of Federals near Vicksburg.

But within days, everyone knew that Vicksburg had fallen, meaning the loss of the Mississippi River, and that Lee was beaten and forced to retreat. "Yesterday we rode on the pinnacle of success," chronicled Josiah Gorgas, chief of the Ordnance Department. "[T]oday absolute ruin seems to be our portion. The Confederacy totters to its destruction." When word arrived at Libby Prison about the loss of Vicksburg, the Federal prisoners burst out in chorus, singing "The Star-Spangled Banner" and "John Brown's Body" until midnight.[78]

It was not only the prisoners who were causing a ruckus. The *Richmond Dispatch* reported on July 8 that Margaret Barrett was arrested for attempting to force her way into Libby Prison "to furnish the Yankee with bread." She was only one of many sympathetic to the Federals confined in the old tobacco warehouses. Elizabeth Van Lew became the most famous, a leader in Richmond's Unionist underground. While she was a Richmond native, she did not hold pro-Southern views. After the start of the war, Van Lew was able to work her way into the prison and hospital systems, providing food and aid to the Federal prisoners. Prisoners and bribed guards soon began passing along information to Van Lew, who used a network of white and African American men and women to smuggle information to Federal forces outside Richmond. Many believe that Van Lew was able to place a family slave, Mary Richards Bower, inside the Confederate White House as a spy. Yet another member of this underground was Samuel Ruth, superintendent of the Richmond, Fredericksburg and Potomac Railroad. Not only did Ruth send information through the lines, but he also slowed down the shipment of freight, including supplies for the Army of Northern Virginia. On two or more occasions, Lee complained of the lack of "zeal and energy" in railroad management. Between October 1861 and March 1862, there were at least fourteen trips by Pinkerton agents into and out of the Confederate capital. Confederate officials were on the lookout for the spies and those disloyal to the Confederacy. After Davis's proclamation of martial law within ten miles of Richmond in 1862, General Winder set to work, appointing Colonel John Porter provost martial and dividing the city into two districts. Just a couple of weeks after martial law was declared, Winder had placed twenty-eight men and two women in Castle Thunder for suspected disloyalty.[79]

Castle Goodwin and, later, Castle Thunder were considered some of the "most dreaded political prison[s] in the South." The Castle Thunder complex occupied three tobacco warehouses on Cary Street. By the summer of 1862, the number of prisoners at Castle Thunder was estimated at 1,450 men and women. Thomas P. Turner, the prison commander, wrote that

A History

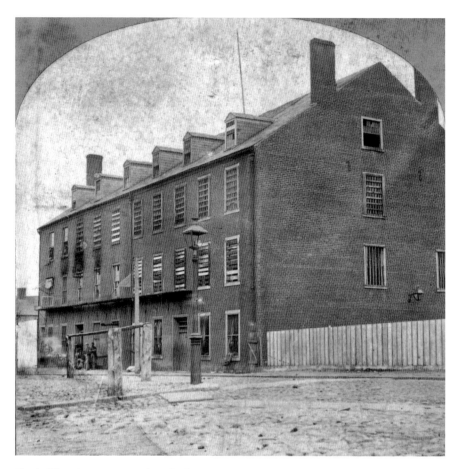

Castle Thunder was a complex of tobacco warehouses converted into a prison to house civilians, political prisoners, those charged with treason and spies. *Library of Congress.*

Castle Thunder was "the worst in the land…Some of the most desperate men in the Confederacy are there." One of the buildings held Confederate deserters and disloyal citizens. Another held African Americans and women, while the third was reserved for Federal deserters. A yard out back, enclosed by a fence, contained latrines, a gallows and a place for execution by firing squads, although it seems that most executions took place at Camp Lee. The camp was the site of the execution of Pinkerton agent Timothy Webster on April 29, 1862. Webster had operated out of the Monumental Hotel in Richmond for several months before being ratted out by two other captured Pinkerton men, Price Lewis and John Scully. Probably the most famous inmate at Castle Thunder was Dr. Mary E. Walker, an abolitionist assistant

surgeon for an Ohio regiment who was captured in April 1864 near Tunnel Hill, Georgia. She was exchanged that August.[80]

Prisoners, whether at Castle Thunder or Libby Prison, had plenty of time to devise escape attempts and to put their plans in motion. Some attempted to don civilian clothes and simply walk out of Castle Thunder. Others hid in large groups being transferred elsewhere. Some attempted to bribe the guards, while others cut their blankets into strips and tied them together to make ropes. In January 1863, a couple of inmates successfully dug through a rear wall, only to be captured while waiting for a train. The following November, 35 Federal soldiers who had deserted to the Confederacy cut a hole through their second-story prison room and then cut a hole in a fireplace and proceeded to dig a tunnel fifteen feet into an alley. A week later, all but 6 had been recaptured. The most famous tunneling escape was at Libby Prison in February 1864. Federal officers carved out a wall behind their stove and down into the cellar of the building. From the cellar, they began tunneling out of the building. Working at night, they dug for several weeks, using clamshells and pocketknives as tools. Forty-seven days after they started, the tunnel was complete, and 109 escaped through the "Great Yankee Tunnel"; 2 of the prisoners drowned in the river, and 48 more were recaptured. The rest escaped.[81]

If an escaped prisoner could elude the guards and detectives searching for him, he might be able to find one of the safe houses. Elizabeth Van Lew supposedly kept "two or three bright, sharp colored men on the watch near Libby Prison who were always ready to conduct an escaped prisoner to a place of safety," wrote one Federal officer. She was rumored to have a secret room in her attic. Once the clamor had died down, escapees were guided through the defenses of the city and toward Federal lines.[82]

Some Federal prisoners were able to smuggle messages out of Richmond. Brigadier General Neal Dow, captured in July 1863, was incarcerated in Libby Prison and able to get at least two missives to Lincoln, detailing the deplorable circumstances of his fellow prisoners. From November 1863 through March 1864, there were at least three attempts by Federal soldiers to liberate prisoners in Richmond. An estimated 11,650 Federal prisoners of war were in Richmond at the end of 1863. In early November, word reached Confederate officials of an uprising planned by Federals on Belle Isle. Prisoners were to overpower the guards and then move toward the east. Federal cavalry were to intercept them and cover their movements once outside Confederate lines. Confederates responded by doubling the guards at the prisons in Richmond and adding additional cannons at Belle Isle.

According to the newspaper, "the plot withered." The next attempt came in February 1864. Learning that Confederate officials planned to move Federal prisoners in Richmond to Georgia, a scheme was devised to send troops to capture the bridge across the Chickahominy River, followed by the works closer to Richmond. Once in Richmond, the prisoners could be released. The raid began on February 6. It is possible that a prisoner, recently granted clemency by Lincoln and able to bribe his way out of Federal custody, was able to warn Confederates of the impending attack. Regardless of how they knew, Confederate forces were waiting at the bridge over the Chickahominy River, and the Federals called off the attack.[83]

One of the most controversial raids of the war took place in Richmond during late February and early March. Federal brigadier general Judson Kilpatrick led a group toward the Confederate capital, with plans to free the prisoners and burn parts of the city. Kilpatrick fared little better than the raiders had a couple of weeks earlier. His attacking columns were halted, and many Federals were wounded and killed. Among those was twenty-one-year-old Ulric Dahlgren. Papers found on Dahlgren's body sent waves of dread and anger through the Confederacy, and especially Richmond. According to these papers, after freeing the prisoners on Belle Isle, the Federals were to "cross the James River into Richmond, destroying the bridges…and exhorting the prisoners to destroy and burn the hateful city; and…not allow the Rebel leader Davis and his traitorous crew to escape." The second document was even more startling: "The men must keep together and well in hand, and once in the city it must be destroyed and Jeff Davis and the Cabinet killed." Richmond was in a state of shock. A message was passed under a flag of truce between Lee and the Federals, asking if the actions found in the papers were authorized by the United States government. Washington, D.C. denied the orders were legitimate. Lincoln personally knew Dahlgren, and the attempts to liberate the captives in Richmond ceased.[84]

Davis was the target of other attempts on his life. Just before Christmas in 1863, a bullet whizzed past Davis as he took an evening ride through the streets of Richmond. An interviewer stated that Davis claimed later that he had been shot at twice in his sojourns around the city. In another instance, an arsonist, possibly one of the slaves employed by the Davis family, set fire to the basement of the executive mansion. The blaze was confined to just one room. It was not until February 1864 that a full-time security detail was formed for the Confederate White House. Later on in 1864, it took 150 guards daily, or 450 on a three-day rotation, to protect places like the capitol, executive mansion and government offices in the old customshouse.[85]

Franklin Street was considered one of Richmond's finest residential blocks. In 1864, Robert E. Lee's wife, Mildred, and his daughters lived at 707 East Franklin Street, a home that had previously been occupied by Lee's son, G.W.C. Lee. Robert E. Lee returned to the house after surrendering at Appomattox Court House in April 1865. *Library of Congress.*

On May 2, 1864, the first session of the Second Confederate Congress commenced at the Virginia state capitol. A multipronged attack across the Confederacy began a little over a day later. Federal soldiers crossed the Rapidan River and, for the next six weeks, were constantly attempting to get between Lee's army and Richmond. Thirty thousand additional soldiers began advancing from the east from City Point and Bermuda Hundred. In the western theater, Federal soldiers began advancing through north Georgia in an attempt to capture the city of Atlanta.

Fighting to the north of Richmond was unlike that in the previous years. Instead of retreating once their advance was checked, the Federals moved east. There were also reports of Federal navy sailing up the James River, of infantry advancing up the peninsula and Federal infantry moving up from Bermuda Hundred. Not since the Seven Days Battles in the spring of 1862 had Richmond been ablaze with such excitement. On several occasions, the tocsin on the statehouse grounds sounded, calling for the militia. The Departmental Guards had already marched out, and the militia soon followed. A call was issued on May 9 for all men able to take up arms to report to Franklin Street to be organized into companies and armed. Another call was issued on May 11, and according to Jones, the "armory was open…and all who desired them were furnished with arms." Even Castle Thunder produced about three hundred men, in two companies, who were reported "doing excellent service" at the front. The peal of cannons could be distinctly heard in the heart of the city.[86]

Wounded were streaming into the city. The *Examiner* reported that between May 6 and May 20, the Seabrook Receiving and Wayside Hospital received 4,419 wounded Confederates. Of that number, only 73 had died. That number did not include around 300 wounded officers at the Officers' Hospital at the old Baptist Female Institute. There were numerous ranking Confederate officers at the Officers' Hospital and other facilities across the city. Major Pickens Bird of the Ninth Florida Infantry was wounded in June at Cold Harbor and taken to the Howard's Grove Hospital. He died of wounds on June 6, his final words reported as, "I am proud to have died a Confederate soldier." His remains, and a host of others, were interred in the officers' section at Hollywood Cemetery. Brigadier General Leroy Stafford was struck in the shoulder at the Battle of the Wilderness. He died at the Officers' Hospital on May 8 and was taken back to Louisiana for burial. Tar Heel cavalry brigade commander James B. Gordon was wounded on May 12, at Meadow Bridge. He was also taken to the Officers' Hospital, where he died on May 18. Gordon's remains were taken back to North Carolina.[87]

No loss stunned Richmond society in 1864 like that of cavalry hero J.E.B. Stuart. On May 11, Stuart's troopers intercepted Federal cavalry at Yellow Tavern, six miles north of Richmond. While the Confederates were able to hold off the enemy, Stuart was mortally wounded in the battle. He was taken to the Richmond home of Dr. Charles Brewer, his brother-in-law. Many came to visit with him, including Jefferson Davis. Stuart died of his wounds on May 12, three hours before his wife, Flora, and their children could reach him. When told of his death, Lee stated that he could

"scarcely think of him without weeping." Stuart's funeral took place the next day at St. James Episcopal Church. Davis was present, along with members of Congress and other civil and military officials. His pallbearers included Generals John Winder, Braxton Bragg, John McCowan, Robert Chilton and Alexander Lawton; Commodore French Forrest and Captain Sidney Lee of the navy; and Mr. George W. Randolph, former Confederate secretary of war. Following the service, his remains were escorted to Hollywood Cemetery for interment.[88]

The thousands of wounded produced by what became known as the Overland Campaign taxed the medical facilities in Richmond. Hospitals were reorganized in 1863 in an attempt to standardize care and to reduce costs. Many of the private hospitals were closed. In 1863, battles producing large numbers of wounded were limited. This was not the case in 1864, when the fighting was encircling Richmond. Several local newspapers ran advertisements asking for ladies who had experience as nurses, or who had servants experienced as nurses, to report to Howard's Grove, Winder and Jackson Hospitals, along with the Receiving Hospital. "Those who cannot render aid," the ad continued, "are requested to contribute such delicacies as are usually prepared for the sick." It was not just nurses in short supply. William Carrington, Confederate medical director, put out a call for experienced doctors at all of the hospitals in Richmond.[89]

There were many who answered the call; Constance Cary's mother was one of them. Cary recalled after the war:

> *My mother, for some time inactive in her nursing, declared she could rest no longer. She had been out to visit the hospital at Camp Winder, in a barren suburb of the town, where the need of nurses was crying. My aunt, Mrs. Hyde, deciding to accompany her, they were soon installed there, my mother as division matron, in charge of a number of rude sheds serving as shelter for the patients, my aunt controlling a dispensary of food for the sufferers. It had been proposed that I should remain in town with friends, but my first glance at my mother's accommodations in the camp made me resolve to share them and try to do my part. To the nurses and matrons was allotted one end of a huge Noah's Ark, built of unpainted pine, divided by a partition, the surgeons occupying the other end. Near by were the diet kitchens and store-rooms, around which were gathered wards and tents, the whole camp occupying an arid, shadeless, sun-baked plain, without grass or water anywhere, encircled by a noxious trench too often used to receive the nameless débris of the wards. To my mother, and myself as a volunteer aid*

to her, was assigned a large bare room with rough-boarded walls and one window, a cot in each corner, two chairs, a table, and washing apparatus.[90]

Fighting to the north and east of Richmond lasted through mid-June. Every attempt by the Federals to get between Lee's army and Richmond failed. Yet the battles produced some fifty-five thousand Confederate killed, wounded and missing. And there were very few replacements coming to swell the depleted Confederate ranks. A few new faces were seen. The Battle of New Market, Virginia, was fought on May 15, 1864, and to ensure Confederate victory, the cadets from the Virginia Military Institute were put in at the last moment. Following the battle, the cadets were in Richmond, parading on Capitol Square and listening to speeches from Davis and new Virginia governor William Smith. The cadets were quartered at Camp Lee, and on May 27, while drawn up on the capitol grounds, they were presented a new state flag and a resolution of thanks adopted by the Confederate Congress. With the burning of their campus in Lexington a few weeks after the Battle of New Market, Richmond became home to the cadets.[91]

One newspaper editor painted this picture of Richmond as the capital entered the most trying portion of the war:

> *WHAT RICHMOND HAS GIVEN UP to aid the Confederate Government in the prosecution of this war, has never been rightly estimated nor appreciated out side of Virginia. Her public buildings and institutions have been mainly monopolized by the general Government, of course with the consent of the authorities, for what would not the citizens of Richmond give if it were asked of them? This commenced with the transfer of the seat of Government from Montgomery to Richmond. First, the State Capitol was occupied by the Confederate Congress; the Mechanics' Institute by the War Department; the City Postoffice by the Treasury Department. The Mechanics' Institute has no longer an existence, and the Postoffice is removed to more contracted quarters under the Spotswood.—Since the army of "occupation" came our hotels have been pressed to supply other government accommodations; court martials sit in our churches; committees in our school houses; Yankee prisoners cram our warehouses; the wounded fill our dwellings; the refugees are quartered upon us by the thousands, and the original citizens are pushed into the smallest possible corner. We do not make these assertions in a spirit of fault finding; far from it. Richmond does not murmur, while the grand old mother of States and statesmen utters*

Tredegar Iron Works was founded in 1836 and was the major supplier of high-quality munitions during the war. It survived the fires that swept through the area and was back in business by the end of 1865. *Library of Congress*.

> *not a groan, no matter how much friend and foe trample upon and tear her fair bosom. She battles and suffers in hope, and looks for the day of her deliverance.*[92]

Richmond was the primary target of many of the Federal thrusts. The Confederate capital allowed the principal Confederate armies in the east to exist. Without Richmond, these armies would soon be without arms, munitions and food. Some of those industries, like Tredegar Iron Works, existed before the war. Once the conflict began, much of the production changed from building locomotives and casting cannons for the United

States government to rolling iron plate for ironclads and casting cannons for the Confederate States. It is believed that Tredegar created 1,043 cannons between April 1861 and April 1865. Once Richmond became the capital, the government established a Clothing Bureau to supply troops. The bureau was divided into two parts. One was the Shoe Manufactory and the other the Clothing Manufactory. By 1862, the shoe portion alone had turned out 320,000 pairs of boots. The Clothing Bureau employed sixty tailors who cut out the pieces of each uniform. These pieces were bundled with the necessary trim, buttons and thread and were issued to seamstresses who sewed them together. The seamstresses were paid by the completed piece. In 1862, the Clothing Bureau in Richmond employed two thousand women. In July 1863, one newspaper noted that the clothing depot furnished work "to many worthy ladies," but that some of the seamstress had to wait for hours to pick up their blanks. Many of the ladies took the materials home and finished the jackets there. It was widely known that there was a preference for women whose husbands were in the army. Battle flags for Confederate regiments assigned to the Army of Northern Virginia were also sewn by women at the Clothing Bureau. The Richmond Arsenal, with several locations in Richmond, produced nearly half of the ordnance needs of the Confederacy. By January 1, 1865, the facility had produced more than 1,600 cannons, 900,000 rounds of artillery ammunition, 350,000 rifles, 6,000 revolvers and more than 72 million cartridges for small arms. Like the Clothing Bureau, the Richmond Arsenal employed women and children to offset the dearth of adult male laborers. On March 13, 1863, an explosion in the arsenal's laboratory on Brown's Island killed forty-five workers. Irish immigrant Mary Ryan was attempting to knock loose friction primers from a board when one of the primers ignited, setting off an explosion in the room. Most of the killed and wounded were women and children, including thirteen-year-old James Curry and sixteen-year-old Samuel Chappell. Women were preferred for the work of assembling cartridges due to their small, nimble fingers.[93]

The war years brought changes for the African Americans in Richmond as well. Free blacks were impressed into service to work on fortifications surrounding the city. Many slaves were hired by the Confederate government or other local businesses. There were nearly 100 slaves manning the canal boats, steamers and barges churning through local waters. Slaves were employed in local factories. The Manchester Cotton and Wool Manufacturing Company had no slaves employed prior to the war. By 1863, there were 122 helping in the production of cloth. The

Virginia Central Railroad employed over 300, while Tredegar Iron Works had more than 200 by 1864. Slaves also worked in area hospitals. General Hospital Number 8, at the old St. Charles Hotel on Fifteenth and Main Street, employed 71 slaves in 1862 and 1863. Slaves worked as attendants, ambulance drivers, cooks and washers at the hospitals. By 1862, the Confederate government was the largest single employer of slave workers in Richmond. Prices for slaves increased during the war, just as everything else did. One local slave owner saw the prices of three nineteen- to twenty-year-old males go from $1,300 to $4,500 each. Slave traders often bought slaves in the Deep South and brought them to Richmond, imprisoning them in the jails on Wall Street. Robert Lumpkin's slave jail, located in Shockoe Bottom, was known as "the devil's half acre."[94]

Unable to defeat Lee's army or capture Richmond, Federal forces moved south of the Confederate capital, eventually laying siege to Petersburg. There were five railroads converging in Petersburg. Without these lines, the Confederate capital would starve. Gradually, the Federal forces moved west, cutting important railroads and other supply lines into Petersburg. When the Weldon Railroad was severed in August 1864, supplies coming from North Carolina had to be unloaded at Stony Creek Station, some sixteen miles south of Petersburg. From there, the wagons moved to Dinwiddie Court House and then via the Boydton Plank Road into Confederate lines. Federal activity in the spring and summer of 1864 in the Shenandoah Valley destroyed many supplies in the "Breadbasket of the Confederacy." Even the weather seemed to be conspiring against the Confederacy. War Bureau chief Robert Kean noted in July, "A grievous drought lasting for six to eight weeks has afflicted the country." Very little rain fell until mid-August.[95]

By fall, the problem had become an excess of rain instead of a lack thereof. "During this damp weather the deep and sullen sounds of cannon can be heard at all hours, day and night," chronicled Jones on the first of November, 1864. Jones wrote that there was food available in the markets, but none could afford to buy anything. In contrast, Sallie Brock wrote that the local markets "presented a most impoverished aspect. A few stalls…sold poor beef, and some at which a few potatoes and other vegetables were placed for sale, were about all that were opened in Richmond markets…As a general rule a Richmond dinner at this time consisted of dried Indian peas, rice and salt bacon, and corn bread." Between April 1864 and February 1865, the City of Richmond spent $1,700,000. In that same time frame, the city collected just under $450,000 in taxes, plus almost $1 million in the sale of railroad bonds. That still left a deficit of over $300,000. The city responded

by tripling the tax rate. Many people simply had to tighten their belts even more. St. Paul's Episcopal Church started the Richmond Soup Association. Members of the group visited with the poor and could distribute tickets for free soup and bread.[96]

Even with the crippling condition of the economy, there was still a level of gaiety through certain portions of Richmond society. Some held starvation parties. Edward Alfriend recalled attending several such affairs during the war years. There was never any supper served, Alfriend wrote, and often, the young ladies would be attired in the gowns of a grandmother or great-grandmother. On one occasion, while "the dancing was at its height and everybody was bright and happy," the hostess, a widow, "was suddenly called out of the room." Alfriend later learned that her son had been killed that evening. The height of the social calendar was the wedding of Brigadier General John Pegram to Hetty Cary at St. Paul's on January 19, 1865. One "of the handsomest and most lovable men I ever knew wed to the handsomest woman in the Southland," wrote Henry Kyd Douglass. Three weeks later, Pegram was killed in the fighting along Hatcher's Run. His funeral followed at St. Paul's, with his new bride in attendance at the church where they had so recently been wed. Some in Richmond remonstrated against social events at such a time. Judith McGuire felt that the parties attended by the young who got home at respectable hours were acceptable. But those that served "the most elegant suppers…cakes, jellies, ices in profusion, and meats of the finest kinds in abundance" were in poor taste. Phoebe Pember wrote, "There is certainly a painful discrepancy between the excitement of dancing and the rumble of ambulances that could be heard in the momentary lull of the music, carrying the wounded to different hospitals."[97]

Debate was just as heated in the hallowed halls of Congress. There were many within the Second Confederate Congress who were opposed to Jefferson Davis and wanted the war to end. Thomas De Leon wrote a few years after the war that everyone could see "that the Government was divided against itself; for the worse than weak Congress—which had formerly been as a nose of wax in Mr. Davis' fingers—had now turned dead against him. With the stolid obstinacy of stupidity it now refused to see any good in any measure, or in any man, approved by the Executive." Newly elected North Carolina congressman James Leach proposed that delegates from the states request Davis to offer the United States a ninety-day armistice. During this time, talks could begin, regarding peace and state sovereignty and independence. If the United States accepted, then the Confederate Congress could submit the proposal to the states. The measure

was tabled. There were several proposals for peace conferences, even as late as February 3, 1865, when Lincoln met with Alexander Stephens and others at Hampton Roads, to the east of Richmond. As with the other conferences, the one at Hampton Roads came to naught. There were also physical confrontations over policy. Congressman Benjamin Hill of Georgia once threw an inkwell at Alabama's William Yancey, cutting Yancey on the cheek and spilling ink on the Senate floor. In another incident, a woman horsewhipped Missouri congressman George Vest on the floor of the House for legislation dealing with government-employed clerks.[98]

There had been talk of abandoning Richmond for several months before the end came. Jones noted in his diary on December 24, 1864, that there was a rumor floating about that the capital was to be moved to Lynchburg. Again on January 13, 1865, he noted, "A great panic still prevails in the city, arising from rumors of contemplated evacuations." Things were not better a month later when the *Richmond Dispatch* noted that the city "is again reported to be in process of evacuation, shipping blown up, and all that sort of thing." That same paper reported in early March a piece from the *New York Times*, of which publication espoused the belief that any day news would come across the wire of the evacuation of Richmond, with Lee's army moving to Danville or even into North Carolina. Some departments were even boxing their papers, in the event that the capital was to be abandoned. John Leyburn, visiting in Richmond, actually noticed one morning that the Confederate flag was flying upside down at the Virginia state capitol, where the Confederate Congress was getting ready to wrap up its final session.[99]

On April 2, 1865, Federal troops broke through Confederate lines below Petersburg. Postmaster Reagan, at the War Department, received a telegram from Lee stating that Richmond must be evacuated. Reagan took the note to Davis, who was on his way to St. James. While he was attending church, additional notes arrived, prompting Davis to leave and proceed to the old customshouse. Davis called his cabinet together, along with Governor Smith, former governor Letcher and Mayor Mayo, informing them that the capital would be lost. At the same time, Davis wired Lee, asking for more time. While some preparation had been made, such as boxing up machinery at the Confederate States Arsenal and shipping it to Danville and the shipment of the papers from the State Department to the Danville Female College, much still remained undone. Lee ripped up the note, telling an aide, "I am sure I gave him sufficient notice." Government employees began feverishly packing important papers and documents. One of Davis's aides, John Taylor Wood, commented on packing a few things at his own home,

A History

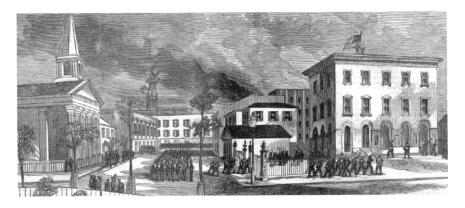

Confederate soldiers were leaving Richmond as Federal soldiers entered, running flags up on various buildings and helping fight the fires that threatened to destroy the entire city. *Library of Congress.*

then at the president's office and finally at Davis's home. Some of the papers from the War Department, Navy Department and Treasury Department were sent to Charlotte, while other papers, such as those from the surgeon general, commissary general, signal office, army intelligence office and possibly others, were piled in the streets of Richmond and set on fire.[100]

Richmond's city council met at 4:00 p.m. to discuss the situation. Two companies of militia were left in an attempt to provide some level of law and order. Any liquor in the city was ordered to be destroyed. Mayor Mayo was authorized to meet with the Federals and surrender Richmond. Judith McGuire noted in her diary that everyone who could leave Richmond was in the process of doing so. Phoebe Pember wrote, "Delicate women tottered under the weight of hams, bags of coffee, flour and sugar." Government officials had opened the supply depots to the general population to prevent their falling into enemy hands. "Invalided officers carried away articles of unaccustomed luxury for sick wives and children at home. Every vehicle was in requisition, commanding fabulous remuneration, and gold and silver the only currency accepted." Another witness wrote that "fierce crowds of skulking men, and course, half-drunken women, gathered before the stores. Half-starved and desperate, they swore and fought among themselves over the spoils they seized." Banks burned worthless paper money, while others rushed with whatever containers could be found to collect the alcohol running through the gutters.[101]

Davis walked back to the White House that evening. Varina and the children had already fled the city, traveling toward Charlotte on March 29. He packed a few items, walked around the house and, at about 7:00 p.m.,

lit a cigar as he stepped into a carriage to bear him to the depot. Bedlam ensued at the Richmond and Danville Railroad depot. Guards were placed around the structure, and only those with a pass from the War Department could board. Various overburdened locomotives pulled out of the station, one with treasury employees, another with the quartermaster's department. The train bearing Davis and the Confederate cabinet was scheduled to leave at 8:30 p.m., but it was 11:00 p.m. before it pulled out of the station. Newly appointed secretary of war John C. Breckinridge remained behind. Davis offered no words of farewell to the people of Richmond as the train headed out into the darkness.

Richmond was soon ablaze. All naval vessels were destroyed. Cotton, tobacco and any supplies that could not be transported were set on fire. These fires, along with the ones that had been set by looters, spread across the city, leaving rampant devastation. One citizen had managed to sleep through part of the events, but the explosions at the arsenal roused him from his slumber. "The earth seemed fairly to writhe as if in agony, the house rocked like a ship at sea, while stupendous thunders roared around," he wrote a year after the ordeal. Another eyewitness recalled "a dense pall of smoke" that

> hovered low over the entire city; and through it shone huge eddies of flames and sparks, carrying great blazing planks and rafters whirling over the shriveling buildings. Little by little these drew closer together; and by noon, one vast, livid flame roared and screamed before the wind, from Tenth street to Rockett's; licking its red tongue around all in its reach and drawing the hope—the very life of thousands into its relentless maw!

Some of the warehouses were filled with loaded artillery projectiles. As the fires swept through the brick structures, they created enough force to lift the shells into the air: "With hissing fuses, they burst at many points, adding new terrors to the infernal scene; and some of them, borne far beyond the fire's limit, burst over the houses, tearing and igniting their dry roofs." In the end, an estimated nine hundred homes and businesses were destroyed. These included two hotels; all of the banks; three newspapers; and numerous mills, drugstores, groceries, saloons, shops and warehouses, along with the Henrico County Courthouse and several government buildings.[102]

Federal soldiers moved into Richmond quickly on April 3, stacking their arms and even helping to fight the fires ravaging the downtown area. The soldiers quickly captured the capitol building and ran up flags belonging to

A History

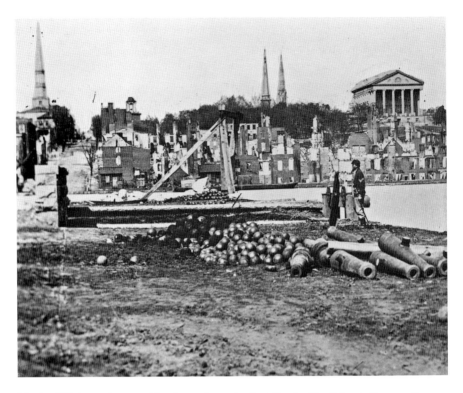

Much of Richmond was nothing but a charred ruin, left so by Confederate forces setting fire to military stores and warehouses full of cotton and tobacco as they fled the city on the night of April 2, 1865. *Library of Congress*.

the Fourth Michigan Cavalry. Mary Fontaine watched as a "blue horseman" took "possession of our beautiful city; watched two blue figures on the Capital, white men, I saw them unfurl a tiny flag, and I sank on my knees, and the bitter, bitter tears came in a torrent." Richmond was no longer the capital of the Confederacy.[103]

Chapter 4

Danville, Virginia

April 3 to April 10, 1865

Danville was astir with anticipation. Mayor James Walker had received a telegram alerting him that the president and other Confederate officials were on their way to the bustling community on Virginia's Dan River. Walker assembled a committee and called for a public meeting at the Masonic Temple. The trains coming out of Richmond, nine in total, were bringing hundreds of officers and government employees who would need lodging, and it was time for Mayor Walker and the local citizens to take responsibility. In just a matter of hours, Danville was positioned to become the third capital of the Confederacy.

While Danville was already a booming town prior to the war, the hostilities between the South and North had stretched it to its capacity. Founded in 1793, by the 1820s and 1830s, Danville was considered the "cradle of leaf marketing and manufacturing." Tobacco was big business, and by 1860, the profitable crop had swelled the population to 3,510. Danville boasted five schools, five banks, four churches, two newspapers and more than forty businesses devoted to the tobacco industry. During the early days of the conflict, Danville rose quickly to an even greater importance. A Confederate Sustenance Department was established in the town, along with an arsenal. At the latter, workers manufactured everything from cartridge boxes to horseshoes. Weapons were repaired in Danville, and the Danville Manufacturing Company produced large amounts of wool kersey, cashmere and jeans-wool, all shipped to Richmond and turned into uniforms. Several of the tobacco warehouses were used as prisoner of war camps for captured

Federals, and a Confederate hospital was constructed within the limits of the town. Additionally, Danville and the surrounding Pittsylvania County sent an estimated 4,000 men to serve in the Confederate army. In 1864, with the completion of the Piedmont Railroad linking the tobacco town with Greensboro, North Carolina, Danville's prominence increased. As the Confederacy's hope for survival looked bleaker in the winter of 1865, the depot capacity in Danville expanded. At one point, just prior to the fall of Richmond, the rifle manufacturing equipment from the Richmond Arsenal was boxed up and shipped via railroad to the city of tobacco warehouses and frontage on the Dan River.[104]

The Confederate government's trip from Richmond to Danville took sixteen grueling hours. Frequently, the train had to stop to take on wood and water. Congressman Horatio W. Bruce, traveling with the president, recalled that at every stop the locomotive made, crowds of people thronged "to the train…to make inquiries" regarding the fall of Richmond. "Everyone sought to see, shake hands with and speak to the President, who maintained all the way a bold front, gave no evidence by word or appearance of despair, but spoke all along encouragingly to the people." Two miles east of South Boston, Davis's train screeched to a sudden and unscheduled halt. A train that preceded the president's had derailed following the collapse of a floor in a boxcar, killing five Georgia soldiers. Once the victims were buried and the cars reset on the tracks, the trains resumed their journey. One estimate was that the president's train only moved an average of ten miles per hour. Between four and five o'clock in the afternoon of April 3, Davis and his government pulled into the Danville Depot. Mallory noted in his diary that a large crowd had gathered to welcome Davis and that "the President was cordially greeted. There was none of the old, wild, Southern enthusiasm," he continued in his diary; "there was that in the cheers which told almost as much of sorrow as of joy." Davis later recalled in his memoirs that the "patriotic citizens of Danville gave the group an 'Old Virginia welcome,'" and Anna Trenholm described "an immense crowd."[105]

Mayor Walker's appeal for assistance produced a small squadron of carriages and wagons to help unload the train of government officials and their baggage. Davis; Mallory; Secretary and Mrs. Trenholm; staff officers Lubbuck, Wood and Johnston; treasury clerk Micijah Clark; and Davis's personal physician, Dr. Alexander Garnett, were all taken to the home of Major William Sutherland, located on a hill overlooking the town. Judah Benjamin and Reverend Hoge were invited into John Johnston's home. Johnston was the cashier at the Bank of Danville. The homes of William

The Capitals of the Confederacy

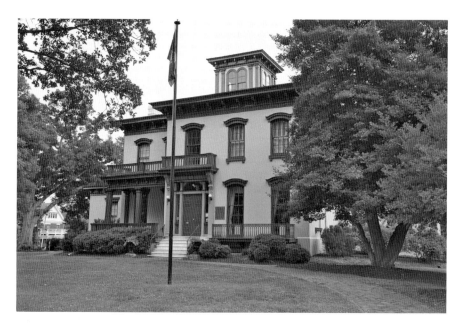

The Sutherlin Mansion in Danville was constructed in 1859. Davis and several others stayed there in early April 1865, waiting for news from Robert E. Lee and his army. *Michael C. Hardy.*

Grasty and W.T. Clark also welcomed visitors. Others, such as clerks and government workers, were boarded at the Exchange Hotel and the Turnstall House, both public houses.[106]

Davis was in the dark regarding news from Richmond or from Lee's army. Word had reached them at one stop that the bridges over the James River at Richmond were burned. This demolition was an attempt to prevent the Federal troops from pursuing the trains. Everything else was just a rumor. One staff officer wrote a couple of months later that there was conflicting news, "more in most cases than could be well digested. Lee was giving Grant a fearful castigation; so enfeebled were the Yankees, that, although Richmond was opened to them, they did not enter it—Richmond was in ashes—Richmond was filled with nigger soldiers—Richmond was not disturbed—Richmond had ceased to be—Grant was gathering up his army to fly away—it was not possible for him to hold out against Lee's braves another day."

Each of these stories was passed on by "reliable gentlemen" and "delivered to gaping listeners," of which there were plenty. "It was on that sort of stuff we slept our first night in Danville," concluded the officer.[107]

Everyone began the work of establishing Danville as the Confederate capital on the morning of April 4. Colonel Wood started looking for a

building for Davis to use as a residence and office. Reagan established the Confederate post office headquarters at the Masonic Hall, while Trenholm secured the Bank of Danville as an office. Likewise, Mallory opened an office for the Navy Department, General Gorges the Ordnance Bureau and General Cooper, in the absence of Breckinridge, a War Department office. The latter was located in the Benedict House, which had served as a girls' school prior to the war. Colonel Robert Kean, head of the Confederate Bureau of War, wrote in his diary that the opening of these offices was of great importance: "That the country should see that the government was in operation, though Richmond was evacuated." One staff officer noted that Attorney General George Davis and Secretary of State Benjamin "rested—law and foreign affairs were in abeyance."[108]

Davis set out that same day in the steady drizzle, accompanied by Colonel Robert Withers, to inspect the works around Danville. These works Davis found insufficient for the crisis at hand and ordered improvements to be made at once. Withers, writing many years after the war, recalled that Davis "criticized the location of one redoubt but concluded that the place could not be made tenable against a superior force." Sailors from the naval academy were assigned as guards to protect the Confederate treasury, which was still in a boxcar at the depot. Other sailors were placed in the trenches, serving as infantry guarding the new Confederate capital.[109]

Upon returning to town, Davis communicated with P.G.T. Beauregard via telegram, asking that troops be diverted to Danville to strengthen the few who were already stationed there. Davis met with his cabinet soon thereafter at the Benedict House. This meeting led Davis, upon returning to the Sutherland home, to take pen and paper and draft a proclamation to the "People of the Confederate States." In his missive, Davis stressed, "It is my purpose to maintain your cause with my whole heart and soul." Davis then admitted that severe reverses had transpired, but these reverses were not the end for the Confederacy. Instead, the seceded states were entering "a new phase of a struggle, the memory of which is to endure for all ages, and to shed ever increasing lustre upon our country." No longer would Southern armies be tied to defensive points, but they could now draw the Federal forces from their bases. Virginia might need to be abandoned, but Davis promised to return. "[N]othing is now needed to render our triumph certain, but the exhibition of our own unquenchable resolve. Let us but will it, and we are free." Davis later admitted that, given what was to take place in the next few days, the proclamation "was over-sanguine." The declaration was given to Benjamin, who delivered it to the office of the Danville *Register*. It

was printed on April 5 and sent by telegraph to other newspapers, although just how many of them published the proclamation is unknown. It would be Davis's last official public statement.[110]

Colonel Wood chronicled in his diary that, on April 5, he secured a Danville house for Davis and was working on "fitting it up." This was most likely the Benedict House. However, it does not appear that Davis ever moved out of the Sutherland home. Much of April 5 and 6 were spent in waiting for news from Lee and his army. Mallory recalled that there were "a thousand rumours," floating about Danville. "No news is good news," was the opinion of Benjamin. The president, when questioned by his hostess on Lee's surrender bringing the end of the war, was later described as replying, "By no means. We'll fight it out to the Mississippi River." Davis sent out a locomotive on April 5 with Lieutenant John S. Wise in an attempt to find Lee's army. After running into Federals eight miles below Burkeville, the engineer reversed direction, and Wise disembarked from the train at Meherrin Station. Wise rode off on horseback and found Lee near Rice's Station. After giving his report and receiving a message from Lee to Davis, Wise started back toward Danville. On Thursday, April 6, deserters from Lee's army began to appear in Danville. Yet Davis still did not have credible information.[111]

Around 8:00 p.m. on April 8, Wise dismounted in front of the Sutherland home and, after passing through the guard, found Davis seated at the dinner table with members of the cabinet. Wise gave Davis the short note from Lee and made his verbal report as well. Someone asked Wise if he felt Lee would be able to reach the new capital at Danville. "I regret to say, no," Wise recalled years later. "From what I saw and heard, I am satisfied that General Lee must surrender…after seeing what I have seen of the two armies, I believe the result is inevitable." Wise remembered that his words caused a "shudder" throughout the room. Davis met privately with Wise for a short time afterward and even ordered Wise to return to Lee with dispatches the following day.[112]

On April 9, Lee surrendered the Army of Northern Virginia to Federal forces at Appomattox Court House. Davis and the rest of the cabinet were up early in Danville, attending services at local churches. It was Palm Sunday. Mallory recalled that Davis and the other cabinet members were at their office when, around 4:00 p.m. on April 10, a courier arrived with news of Lee's surrender. "It fell upon the ears of all…like a fire bell in the night," Mallory wrote a few weeks after the event. The message was passed around the room so that all of the cabinet and staff present could read it. Congressman Bruce recalled that the news was "crushing." Chaos followed. Kean recalled in his diary that no orders for evacuation were given to the

As the Confederate government waited in Danville, Robert E. Lee and U.S. Grant were working out surrender details two counties away at Appomattox Court House, as depicted in this idealized illustration. *Library of Congress.*

various bureau offices, "which caused great confusion." Another staff officer wrote that "confusion was supreme." Not helping matters was the weather. The rain had subsided for the previous couple of days, but about the same time that positive word arrived concerning Lee's surrender, the skies opened. With the gloom that the news brought, coupled with the torrents of rain, one officer noted that Danville was "the most miserable place I ever dragged my feet through." Mallory journaled of mud reaching knee deep in places.[113]

Still at the Benedict House, Davis penned a quick note to Mayor Walker and the town council, thanking them for all of the effort they had expended on behalf of the Confederate government. Members of the cabinet dashed about, preparing their personal effects for flight. When Reverend Hoge questioned Benjamin on what he planned to do, Benjamin replied, "I will never be taken alive." Davis returned to the Sutherland home in a carriage. Mrs. Sutherland recalled that she "knew something had happened." She "met them at the door and President Davis told me almost in a whisper that Lee had surrendered and that he must leave town as soon as possible." While the possibility of Lee's capitulation was understood by all, no one had made any preparations to effect the easy removal of the Confederate government.[114]

A train was called for, with an engine, flatcar, stock car, boxcar and passenger coach. Other cars were attached, and eventually the train numbered twelve cars. Departure time was set at 8:00 p.m., but numerous delays kept pushing that time back. One witness recollected that the scene was strikingly similar to that in Richmond a few days before. Reagan sat on top of his trunk; Benjamin likewise sat on some baggage, while Cooper squatted on his valise. Trenholm was so unwell he had to be helped to the depot. Anna Trenholm recalled that the secretary was suffering from neuralgia and originally set out on foot toward the depot. Finding the mud over their shoes, they managed to procure a cart, and after going a short distance, they were able to transfer to an ambulance that had been sent to their aid. One officer recalled that the majority of "the old citizens of Richmond" who had accompanied Davis to Danville, some eight additional trains, along with people on foot and in wagons and carriages, gave up and that there were fewer people on the next leg of the journey south. Guards were placed to keep other people off the train. A seat could not be found for Trenholm, and he was forced to lie on a makeshift bed in a boxcar. It took time to fire up the boiler and produce enough steam to get underway. Mallory recalled that it was 11:00 p.m. before the train left the station and pulled out into the darkness.[115]

"Our train was very slow," Harrison wrote. Just south of Danville, the overburdened steam engine broke down, and Davis and the rest of the passengers waited four hours in the darkness as a fresh locomotive was brought from Danville. Davis, against the wishes of Harrison, allowed General Gabriel Rains to board the train and even permitted one of Rains's daughters to share his own seat in the coach. Harrison recalled that the "young lady was of a loquacity irrepressible; she plied her neighbor diligently—about the weather, and upon every other topic of common interest—asking him, too, a thousand trivial questions." Eventually they resumed their journey, riding through the dark countryside, never knowing just how close the Federal patrols were. Davis was doing the one thing he asserted he never wanted to do: he was abandoning Virginia. However, with Lee's surrender occurring just a couple of counties to the north, the new Confederate capital in Danville was open to capture. Davis and the other heads of state were forced to seek a new home, one protected by a Confederate army.[116]

Chapter 5

Greensboro, North Carolina

April 14 to April 15, 1865

Between 1860 and 1865, Greensboro was transformed from a sleepy little town with a population of 1,050 people to a vital city, which some estimated to contain 60,000 people. Greensboro and the surrounding county of Guilford were best known for the Guilford Court House battlefield. While the battle was a British victory, the British army was wrecked. Like his scrappy Patriot predecessors, Lee had frequently won brilliant military victories over a vastly superior force. Yet now his army lay in ruins at Appomattox Court House. Davis undoubtedly knew the story of Guilford Court House and might have even reflected on the ironies of history as his train ambled down the well-worn tracks during the early morning hours.

Chartered in 1808, Greensboro bore many names. Some considered it the "Athens of the South," due to the large number of schools. Others called the town the "City of Flowers." Despite these earlier, glittering names, the war had transformed Greensboro's character. Educational facilities like the Edgeworth Female Seminary were closed during the war, with the physical structures converted into soldiers' hospitals. There were scores of businesses in town. One observer wrote that "the industrial developments of Guildford resembled that of New England." Textile mills dotted the landscape. Woodworking plants turned out everything from spokes and handles to furniture. The Pioneer Foundry produced ploughs, castings and other tools. In the fall of 1863, Greensboro's importance escalated. East Tennessee came under the control of Federal forces, and the railroad through Greensboro became the direct route from the Deep South. By

May 1864, a line known as the Piedmont Railroad connected Greensboro to Danville. When Federal forces cut the rail lines south of Petersburg in August 1864, Lee's only remaining protected link came through Greensboro and proceeded to Danville and then on toward Petersburg. Greensboro became a major depot on the lifeline of the Confederacy.[117]

The train bearing Davis and most of the cabinet rattled into the station at Greensboro around 8:00 a.m. on April 11. Federal cavalry under the command of Major General George W. Stoneman came within minutes of catching the entire Confederate government. Stoneman's Raid had commenced in the mountains of western North Carolina and proceeded east into the foothills. For a time, his troopers ventured north into Virginia but were back in the piedmont section of North Carolina on April 9. Portions of the command fanned out along the rail line, where, just five minutes after the train bearing Davis passed, they cut the Piedmont Railroad at Reedy Fork Creek. Other Federal cavalry detachments cut the railroad running south as well. Mallory recalled that Davis, learning this news, stated, "a miss is as good as a mile." Upon arriving at the station, Davis delivered a short speech to a group of well-wishers gathered at the depot.[118]

"As April 1865 dawned upon the world Greensboro was no longer the beautiful, quiet, delightful place of yore," wrote a local citizen in 1866.

> *The streets were swimming in mud, and the houses looked as if they sympathized with their deplorable condition…The rumbling of passing cannons, the neighing of frightened horses, the jingling of spurs and clashing sabres, the shrill whistle of the coming engines, the tramp of the soldiery, the movement of wagons, the preparations for battle, the excitement of war and fear, the rushing to and fro of citizens and soldiers, the insubordination of desperate men, the stern mien of our veteran soldiers, the calm, defiant air of our noble commanders and rulers, all presented a scene and sound and aspect never before witnessed or heard in the wild woods of this inland town, and nothing resembling it since the clash of the patriot and tory…in the days of the Revolution which "tried men's souls."*

Greensboro had become one massive sea of humanity. Besides the swell of people trying to escape Federal armies in Virginia, eastern North Carolina and possibly to the west as well, there were thousands of sick soldiers from Virginia hospitals and wounded men from the Battle of Bentonville, fought in mid-March to the east of Raleigh. Added to this were up to twenty thousand soldiers from the Army of Tennessee, all camped in the general vicinity.[119]

Whether it was due to the influx of refugees and sick and wounded soldiers and surplus troops or to the fear of reprisal should the Federal army learn of someone's generosity, the majority of the Confederate cabinet and staff failed to secure lodging in Greensboro. One of Davis's staff officers, Colonel John T. Wood, had, at some point, moved his family to the safety of Greensboro. Wood, who was also Davis's nephew, offered Davis the use of one of the rented rooms. The room was small and furnished only with a bed, a table and a few chairs. Wood's neighbors, along with the landlord, were leery of Davis and the traffic he created. One of Davis's staff recalled that on one day, Davis, Johnston, Breckinridge, Benjamin, Mallory, Reagan and few others were "holding a council of war" in a room that only measured twelve by sixteen feet. On his own accord, Davis chose to return to the railroad and board with the others. It appears that the only cabinet member to obtain a room was Secretary Trenholm. Former North Carolina governor John Morehead collected the ailing Trenholm and took him to the Blandwood mansion. Morehead was known to be very generous, while at the same time, many speculated that since the governor had huge sums tied up in Confederate bonds, he might "cajole the Secretary into exchanging part of the 'Treasury gold' for some of those securities."[120]

The rest of the Confederate cabinet, joined after a day or two by Davis himself, took "up their quarters in a dilapidated, leaky boxcar," according to Mallory. In all practicality, Davis and the cabinet occupied a passenger car, while an additional boxcar served as the capital of the Confederacy. "The 'Cabinet bar' was," Mallory wrote,

> *during those dreary days at Greensboro, a very agreeable resort. Like true men of the world its distinguished hosts did the honors to their visitors with a cheerfulness and good humor, seasoned by a flow of good spirits, which threw rather a charm around the wretched shelter and made their situation seem rather a matter of choice than of necessity. The Navy store supplied bread and bacon and by active foraging of Paymaster* [James] *Semple and others of the party, biscuits, eggs and coffee were added; and with a few tin cups, spoons and pocket knives, and a liberal use of fingers, and capital apatities* [sic]*, they managed to get enough to eat, and to sleep as best they could.*
>
> *The times were "sadly out of joint," just then, and so was the Confederate government. Here was the astute "Minister of Justice," a grave and most exemplary gentleman, with a piece of half broiled "middling" in one hand and a hoe cake in the other, his face bearing the unmistakable evidence*

of the condition of the bacon. There was the clever Secretary of State, busily dividing his attention between a bucket of stewed dried apples, and a haversack of hard boiled eggs; here was a Postmaster General, sternly and energetically running his bowie knife through a ham, as if it were their chief business in life, and there was a Secretary of the Navy courteously swallowing his scalding coffee hot that he might not keep the venerable Adjutant General waiting too long for the coveted tin cup. All personal discomforts were borne not only with cheerful philosophy, but they were made the constant text for merry comment, quaint anecdote or curious story. State Sovereignty, Secession, foreign intervention and recognition, finance, and independence, the ever recurring and fruitful themes of discussion, gave place to the more pressing and practical questions of dinner or no dinner, and how, when, and where it was to be had; and to schemes and devices for enabling a man of six feet to sleep upon a car seat of four.[121]

Despite Mallory's "flow of good spirits…and practical questions of dinner or no dinner," there was business to which to attend. Davis's goal was to devise a plan for the continuation of the war for Southern independence. On April 11, Davis wrote to current North Carolina governor Zebulon Vance. The president had yet to receive official word from Lee but had "little or no hope" that Lee had been able to escape. Davis believed that they had to "redouble our efforts to meet [the] present disaster" and that the people would see the gallant few holding the line, determined "to fight on…and daily rapidly gather strength." Davis also wrote to General Joseph E. Johnston, commanding the Army of Tennessee, then positioned near Raleigh. Davis was planning to visit Johnston as soon as he received some word from Breckinridge. The president wanted Johnston, given the location of Federal troops in Virginia and eastern North Carolina, to designate a place for a junction with Confederate forces in Danville and other forces that might have escaped Appomattox. At 4:30 p.m., Davis asked Johnston to report to Greensboro as soon as possible, which Johnston agreed to do.[122]

That same day, Davis called General P.G.T. Beauregard to meet with him. Beauregard had created a mobile command post: three boxcars that he used to house his staff and their horses. As soon as he learned that the president had arrived, Beauregard set out to meet him. Upon entering the president's car, Beauregard was bombarded with inquiries from the cabinet members. Davis soon arrived and, taking Beauregard to a secluded spot, questioned him about current pressing events. "The facts were far from encouraging, and General Beauregard had a gloomy account to give,"

recorded Beauregard's biographer. Beauregard laid out the strength of the Federals in eastern North Carolina, along with the size of Johnston's force; Federals raiding in western North Carolina and Virginia; and Federal raids in Alabama, north Georgia and from Memphis and Vicksburg into Mississippi.[123]

Johnston arrived in the rail yard in Greensboro about 8:00 a.m. on the morning of April 12. For two hours, he met with Beauregard before being summoned by the president. At this meeting with Davis, Johnston and Beauregard were Benjamin, Mallory and Reagan. The meeting is likely the one referenced by Harrison at the room lent the president by Colonel Wood. Johnston and Beauregard believed they were there to offer opinions on the military state of affairs. "But the President's objective seemed to be to give, not obtain information," Johnston recalled in his memoirs. Davis was going to raise a new army in a matter of weeks, calling on those who had deserted, or never answered the call to enlist, and continue the war. "It was remarked, by the military officers, that men who had left the army when our cause was not desperate, and those who, under the same circumstances, could not be forced into it, would scarcely, in the present desperate condition of our affairs, enter the service upon mere invitation," Johnston wrote. Shortly thereafter, Davis adjourned the meeting, asking the opinion of neither Johnston nor Beauregard. They were informed that Breckinridge was expected that evening.[124]

Upon the secretary of war's arrival, the news of Lee's surrender was confirmed. Breckinridge met with Johnston and Beauregard, and Johnston expressed the belief that the only option the president had left was to terminate the war and that he wished to have the opportunity to recommend that preference to the president. Breckinridge stated he would effect that opportunity. Mallory soon arrived and likewise believed that the sooner dialogue to end the war commenced, the better off circumstances would be. Johnston tried to impress upon Mallory that the suggestion come from one of Davis's "constitutional advisers," but it seems that Mallory passed on the idea.[125]

Davis convened the Confederate cabinet again on the morning of April 13. All were present save Trenholm, who was still ill. According to Johnston, the cabinet had already met an hour or two before Davis summoned the two generals. Davis stated that the setbacks were terrible disasters, "but I do not think we should regard them as fatal. I think we can whip the enemy yet." He then asked for Johnston's views on the subject. After laying out the situation as he saw it, Johnston stated that under the circumstances, "it would be the greatest of human crimes for us to attempt to continue the war." Johnston went on to state what the Confederacy did not have: shops, arms,

ammunitions, money, credit. "I therefore urged that the President," Johnston wrote after the war, "should exercise at once the only function of government still in his possession, and open negotiations for peace." Reagan recalled that the atmosphere of the room was "one of the most solemnly funereal I ever attended, as it was apparent that we must consider the probable loss of our cause." Davis asked Beauregard his views, and Beauregard concurred with Johnston. Davis polled the members of the cabinet who were present. Breckinridge, Mallory and Reagan all agreed with Johnston. Only Benjamin thought they should fight on. Davis then asked Johnston what he thought they should do, adding, "You speak of obtaining terms. You know, of course, that the enemy refuses to treat with us." Johnston advised to let the military open the negotiations. While Davis still had little faith in the matter, he resigned himself with the majority and, with Mallory acting as secretary, dictated a letter to Sherman. The letter described the late losses in Virginia, and in order to prevent "the further effusion of blood and devastation of property," asked for "a temporary suspension of active operations," for "civil authorities to enter into the needful arrangements to terminate the existing war." Johnston signed the letter and sent it to cavalry general Wade Hampton to deliver it to the Federals.[126]

While in Greensboro, Davis and the Confederate government authorized Confederate general Joseph E. Johnston to open negotiations with Federal general William T. Sherman. *Library of Congress.*

Davis and the Confederate government lingered a couple of days longer in Greensboro. A line of retreat for Johnston's army was agreed upon, and the president saw to it that supply depots were awaiting the Confederate soldiers. Word of Lee's surrender filtered through town, causing an already crumbling morale to plummet. There were frequent raids by military and civilians alike on the various depot buildings about Greensboro. At times, guards skirmished with other Confederate soldiers in these raids in an attempt to maintain order. Adding to the confusion, paroled soldiers from the Army of Northern Virginia began to arrive around April 15. Davis, believing that an attempt to negotiate with the Federals was futile and desiring to reconnect with his family, chose to move farther south to Charlotte.

From Richmond to Danville and from Danville to Greensboro, the Confederate government had utilized the railroad to progress. Federal cavalry had destroyed some of the track and bridges, and now Davis and the others had to move overland via horse. According to Mallory, he, Davis, Breckinridge and Reagan, along with three of Davis's staff members, mounted horses. Harrison, one of Davis's staff, had to procure ambulances for the ill Trenholm and for Benjamin and Davis, along with Samuel Cooper. Benjamin, according to Harrison, "firmly announced that he shall not mount a horse until obligated to." One staff officer wrote that Cooper, "seeing the cramped accommodations, grew vehemently angry, and declared he would not go further." Mallory was able to soothe Cooper, and the general was seated next to Benjamin "in a wretched ambulance." The tension of being pursued was obviously taking its toll on the civilian leadership of the Confederacy. Besides the mounted party, there was an escort of about one hundred cavalrymen and a twenty-team wagon train.[127]

The convoy set out on April 15, Good Friday. Nearly everyone who wrote about the ride from Greensboro to Charlotte recorded the wretched conditions of the roads. Harrison wrote that the "earth was saturated with water, the soil a sticky red clay, the mud was awful, and the road, in places, almost impracticable." At times, the ambulances had to leave the roads and travel through fields, and at other times, some of the men had to use fence rails to lift the axles of the ambulances out of the mud. As darkness settled, Harrison found that one of the ambulances, this one carrying Cooper, was stuck. Harrison rode off and found a battery of artillery; the cannoneers came and pulled the wagon out of the mud. Colonel Wood, in his diary, noted that the group spent the night at a Mr. Wyatt's, who, the next morning, presented the president with a filly. Another staff officer, writing in 1866, stated that the group spent the night camped in the woods near Jamestown and "had

a soaking soldier's night of it." On the following day, the party moved on toward Lexington, where they learned of the negotiations between Johnston and Sherman. Johnston requested that Breckinridge be sent back to consult on the matter, and Davis agreed, sending Mallory along as well. They spent the evening in a pine thicket east of Lexington. One of the members of the president's escort recalled seeing "Davis, Breckinridge, Benjamin, Mallory, George Davis, Reagan and Cooper kneeling around a camp-chest, eating supper by the flickering light of a fire and candle." On April 17, the group moved on to Salisbury. Wood noted that the buildings that Stoneman's forces burned a few days ago were still smoldering. Davis slept at the home of a local clergyman. Harrison recalled that he and a couple of others slept on the piazza, guarding the president.[128]

At Salisbury, according to one of the cavalry escorts, the group split. It is possible that Davis and the mounted portion of the party rode ahead. The escort recalled that they spent the night at China Grove, where Benjamin learned by note from Breckinridge of Lincoln's assassination. The anonymous escort also wrote that, the following morning, the wagon train had been captured by a group of "unruly, duplex rebels." Cooper formed a squad of ten men armed with loaded muskets and ordered the "unrulies" to dismount. The situation was diffused, and the party moved on. From Salisbury, Davis's group traveled to Concord, where Davis stayed with the family of Victor Barringer, a local lawyer and former officer in the First North Carolina Cavalry. "There we had the first good meal encountered since leaving Virginia," recalled Harrison after the war.[129]

After leaving Greensboro, Davis stopped at four points, once camping in the woods and staying with sympathetic citizens on the other occasions. Unlike in Danville and Greensboro, there appear to have been no cabinet meetings at these stops; outside of ordering Breckinridge and Reagan to join Johnston for the conference with Sherman, little official work took place involving the Confederate cabinet. After the first night, two of the six cabinet members were absent. Mallory recalled that, on April 18, Davis "was moody and unhappy, and this was the first day on which I had noticed in him any evidence of an abandonment of hope." The loss of the Army of Northern Virginia was a serious blow, and the meetings with Johnston and Beauregard did not offer much cause for optimism. Davis's destination, Charlotte, offered a place yet untouched by the hard hand of war. At least, Davis expected to be reunited with his family, a consolation as he struggled to maintain the hopes of the Confederacy.[130]

Chapter 6

Charlotte, North Carolina

April 19 to April 26, 1865

For the second time in eight days, Federal cavalry nearly succeeded in capturing Jefferson Davis. Weary and saddle-sore, Davis, at the head of the column with a cavalry escort following, rode into Charlotte, North Carolina, on April 19, 1865. At the same time, Stoneman's men were busy destroying bridges and driving away Confederate pickets along the Catawba River, just a few miles to the west. A quick Federal thrust just might have netted them a large prize.

Charlotte played a key role in the Confederate war effort. Almost a century earlier, due to the zeal of local patriots, Lord Cornwallis had found Charlotte a "hornets' nest" upon his arrival in 1780. At the start of the war, Federal officials probably thought much the same. In 1860, the town had a population of just 2,265, a number that had doubled from 1850, brought on by the arrival of the railroad. The North Carolina Military institute opened in 1859, with future Confederate general Daniel Harvey Hill as superintendent. James H. Lane and Charles C. Lee were both instructors at the institute. In 1861, North Carolina governor John W. Ellis ordered the cadets to training camps across North Carolina to instruct new officers and enlisted men on the finer points of becoming soldiers. Local men marched away to serve in the First North Carolina Volunteers and to fight in the Battle of Bethel Church, Virginia, in June 1861.

Governmental officials, looking for a secure location for a naval facility, chose Charlotte in 1862. Personnel and equipment from Norfolk and Richmond, Virginia, and Pensacola, Florida, were shipped into Charlotte

and set up on property leased from local ironworks owner John Wilkes. For three years, the naval facility supplied the Confederate navy with carriages for heavy guns, propeller shafts for ironclads and torpedoes for river defenses. Like many Confederate war industries, there were always shortages of both materials and skilled laborers and mechanics. Regardless, the Confederate naval post in Charlotte worked diligently to fulfill requisitions and, on more than one occasion, the works were enlarged.

Like many other towns and cities on rail lines, Charlotte had hospital facilities. A large structure was built at the fairgrounds for convalescing soldiers, while a wayside hospital was located near the depot, staffed by local ladies ministering to soldiers passing through the area. In mid-1863, the Confederate government sought to develop more wartime industries in Charlotte. A Sulphuric Acid Works, part of the Nitre and Mining Bureau, was established near Charlotte. The acid works provided several different components for the Confederate war machine. In mid-1863 it procured the materials to manufacture saltpeter, one of the key components in gunpowder. In 1864, the old Rudisell Gold Mine was manufacturing sulfuric acid to use in the wet-cell batteries that powered the telegraph. At the same time, fulminate of mercury, used in percussion caps for muskets and rifles, was likewise manufactured in Charlotte. As with the other capitals, private enterprise soared in Charlotte during the war years. J.H. Stevens and Company manufactured envelopes; Pritchard and Shaw, along with S.M. Howell, were making leather goods, including cartridge boxes, harnesses, bridles and saddles. The Rock Island Woolen Mill made jackets for the Confederate army.

While Charlotte was not quite as overcrowded as Greensboro had been, there were plenty of extra people to go around. Naval employees had brought their families in 1862 when the facility moved from Norfolk. As the war went on and more coastal areas came under Federal control, people moved inland and found Charlotte a safe haven. In 1865, Federal prisoners of war were shipped from South Carolina to Charlotte and were quartered there until they were loaded onto the train and sent to Goldsboro to be paroled. During that same period of time, one hundred women working at the Confederate engraving bureau in Columbia were shipped to Charlotte as Federals invested South Carolina. Among those arriving during the final days of the war were none other than Varina Davis, along with her children; Maggie Howell, the president's sister-in-law; two servants; and the daughters of George Trenholm. The party was escorted by the president's private secretary, Burton Howell, and Midshipman James Morgan. They

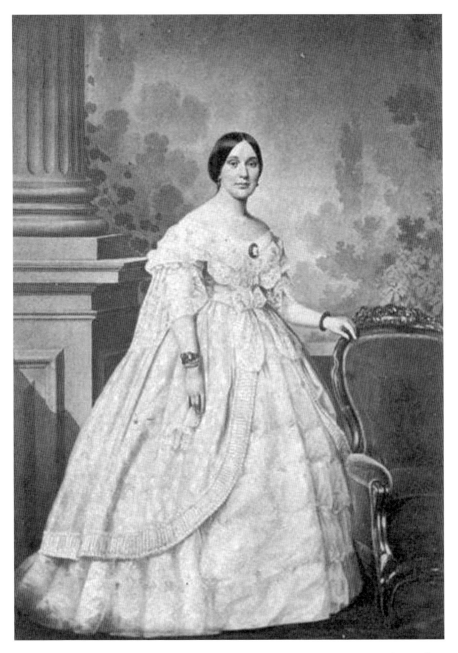

As the Confederate government moved from place to place, so, too, moved the wives and families of many officials, including Varina Davis, First Lady of the Confederacy, who traveled to Charlotte with her children and sister. *Library of Congress.*

rented a house belonging to Abram Weill, a local merchant and member of Charlotte's large Jewish community. Varina found the morale of people in Charlotte exceedingly low, although the post officers, who paid her a visit with their wives, were "exceedingly kind." In her letter to the president, she mentioned other refugees, such as the wife of General Johnston, who was "living with the cashier of the bank and family"; the family of Raphael Semmes, then in the process of heading farther south; and the family of Confederate senator Louis Wigfall, staying with Mrs. Johnston.[131]

More than just refugees wound up in Charlotte. On April 8, a battalion of naval cadets from Richmond arrived on a train with the Confederate treasury. The gold and silver bullion were deposited in the old United States Mint building on Trade Street, along with the papers from the Treasury Department. The papers of the War Department were placed under the charge of William Bromwell, a clerk in the State Department, and shipped to Charlotte in crates marked with Bromwell's initials. These papers were stored in Charlotte, while the papers of the Confederate Congress and post office continued on into South Carolina. Also boxed and shipped to a warehouse in Charlotte were scores of Federal battle flags captured during the war. One Virginia newspaper wrote that Charlotte had already been selected as the new seat of government while the president and Confederate cabinet were in Danville.[132]

As Davis and his party neared Charlotte, a courier was sent ahead to notify Mrs. Davis of their approach. Post quartermaster Major Echols rode out and met the group on the outskirts of town, informing the president that Mrs. Davis had left two days earlier, bound for South Carolina. William Johnston, president of the Charlotte and South Carolina Railroad, greeted Davis and escorted the group to the home of Lewis Bates, a Northern-born telegraph company agent. Confederate cavalry, remnants of John Hunt Morgan's command, came down the street, "waving their flags and hurrahed for 'Jefferson Davis.'" Before the crowd dispersed throughout the town, Davis began giving an impromptu speech to the group of citizens and soldiers who had gathered. In the midst of his exhortation, a note arrived from Breckinridge, announcing the assassination of Lincoln. Davis read the note before passing it on to Johnston, telling Johnston the news the note contained. "There were cries from the crowd 'Read!' 'Read!' whereupon Colonel Johnston read the telegram…announcing…that Mr. Lincoln had been assassinated." Davis was stunned with disbelief at the news. Johnston recalled that Davis "appeared gloomy and despondent." The president then retreated into the Bates home. The editor of the *Charlotte Democrat*

Davis was giving a speech at the Bates home on South Tryon Street when he learned of Abraham Lincoln's assassination. *Public Library of Charlotte-Mecklenburg County.*

was present in the crowd, just feet from the porch where Davis stood, and recalled in 1881, "We heard three or four gentlemen express regret in a low tone of voice, and noticed the very serious countenance which pervaded those standing around." After Davis left, the crowd moved to the public square, where, again according to the editor, "the reading was again called for. Some one mounted the old Hay Scales that then stood on the edge of the pavement, and either read the dispatch or made an announcement of its contents."[133]

While Davis and some of his personal staff stayed at the Bates home, the other cabinet members fanned out across Charlotte. The ailing Trenholm went to the Phifer home and was placed under the care of Dr. Taylor; Stephen Mallory, possibly with John Reagan, went to the Taylor home; and Judah Benjamin stayed with Abram Weill, John Breckinridge with Joe Hilburn and George Davis with William Myers. The various branches and their accompanying staff set up the offices of the Confederate government in the Bank of Mecklenburg on Trade Street. Decades later, it was recalled that both day and night sessions of the Confederate cabinet were held in this building, particularly in the office of the bank president. Davis met with several of his generals, including Wade Hampton and Joseph Wheeler, who were attempting to organize cavalry to continue the struggle. He also received news of the falls of Mobile and Columbus. One citizen recalled that Davis even entertained a party of ladies in the office, coming to pay their respects to the president. Even such mundane assignments as examining a cadet for promotion as a commissioned officer took place in Charlotte. Josiah Gorgas, chief of ordnance and a Confederate brigadier general, recalled forming a board with two other officers and testing the cadet on geography, history,

mathematics and English grammar. The cadet passed, undoubtedly the last officer commissioned by the Confederate government.[134]

Weighing heavily on the minds of Davis and his cabinet as they met in the bank building on Trade Street were the ongoing negotiations between Johnston and Sherman. Johnston wrote Sherman on April 14, asking for a temporary suspension of hostilities so that "civil authorities" could "enter into the needful arrangements to terminate the existing war." Sherman wrote back as soon as he received Johnston's note. He agreed to a cease-fire between his men and the Confederates and agreed to proffer the terms that Grant had given to Lee at Appomattox, but nothing more. "I will add," Sherman closed, "that I really desire to save the people of North Carolina the damage they would sustain by the march of this army through the central or western parts of the State." Johnston received Sherman's reply on April 16, Easter morning.[135]

Johnston and Sherman met the next day at a Durham-area farmhouse owned by the Bennett family. Sherman offered Johnston the same terms that Grant had given Lee a few days earlier. Johnston demurred, wanting instead "an armistice as would give opportunity for negotiations between the 'civil authorities' of the two countries." Sherman stated that this was not possible, as the United States did not recognize the Southern Confederacy or its civil leaders. Johnston further pressed Sherman regarding a complete surrender or permanent cease-fire. After discussions lasting two hours, the meeting broke. They agreed to meet again the next day. Upon arriving at his headquarters, Johnston sent a note to Davis, asking for Breckinridge, who was traveling with Davis, to return. He did, bringing Reagan with him, and Johnston, Breckinridge and Reagan hammered out their terms of surrender. These terms were presented to Sherman on April 18 at the Bennett Farm. The Confederate terms were quickly rejected by Sherman, claiming that they were "so general and verbose, that…they were inadmissible." Sherman then drafted his own terms, calling for the Confederate armies to be disbanded. Weapons were to be deposited at armories at state capitals. State political leaders had to take "the oaths prescribed by the Constitution of the United States." Federal courts were to be reestablished, and a general amnesty was granted to men who resumed "peaceful pursuits." The United States government would not "disturb any of the people by reason of the late war, so long as they live in peace and quiet, abstain from acts of armed hostility, and obey the laws in existence at the place of their residence." Sherman sent a copy of the document to President Andrew Johnson in Washington. Johnston, likewise, sent a copy to Davis in Charlotte.[136]

Davis convened the Confederate cabinet and asked for the members' views, in writing, on both the military situation and the terms that Johnston and Sherman had created. While they agreed that resources for continuing the war were available, they believed that the Southern citizens, after four years of bloodshed and destruction, had lost the will to fight. Stephen Mallory wrote that "even to discuss the convention is to admit independence is hopeless," and that "nine tenths of the people of every state of the Confederacy…are weary of the war and desire peace." Judah Benjamin believed that the "Confederacy is…unable to continue the war by armies in the field." George Davis believed that the terms between Johnston and Sherman should be accepted. John Reagan went so far as to reiterate the obvious: "The officers of the civil government have been compelled to abandon the capital, carry with them the archives, and to close, for the time being at least, the regular operations of its several departments, with no place now open to us at which we can re-establish and put these departments in operation with any prospect of permanency or security for the transaction of the public business." Everyone was in agreement. The Confederate cabinet, formed just four years earlier in Montgomery, had rendered its final guidance.[137]

Yet still Davis hesitated. "The issue is one which is very painful for me to meet," Davis wrote to his wife on April 23. "On one hand is the long night of oppression which will follow the return of our people to the 'Union'; on the other the suffering of the women and children, and courage among the few brave patriots who would still oppose the invader, and/who/unless the people would rise en masse to sustain them, would struggle but to die in vain."[138]

Johnston fired off a telegram to Breckinridge on April 24, stating that he expected a note from Sherman that day, and asked for instructions. That same day, Davis wrote to Johnston that the terms of the convention were approved and that Johnston was to inform Sherman of such. If the government of the United States agreed, Davis would give Johnston further instructions. At 6:30 p.m. that evening, a telegram arrived from Johnston: the United States government had rejected the terms of Johnston and Sherman. Johnston could only surrender his army, nothing more. "I saw Mr. Davis that evening—when he had yielded his last hope," wrote an eyewitness.

> *He was sitting with his eyes fixed on the pages of a pamphlet, and his mind apparently far away. Those that were present moved on tip-toe, spoke seldom and with muffled voices. There was a shadow in that room that Rembrandt could not paint. The spirit of the young Confederacy was now mingling with the shades of Greece, Rome and Carthage; but the*

body still remained, and the vultures were narrowing their great circles and swooping low.[139]

The cease-fire that accompanied the Johnston-Sherman negotiations lasted forty-eight hours. For two more days, Charlotte served as the Confederate capital. Davis advised Johnston to take his cavalry, mount what infantry horses could be obtained and prepare to move to the southwest. Johnston disagreed. He wrote Breckinridge on April 25 that terms should be made for the troops and that a cavalry escort should be given to the president, who should "move without loss of a moment." Davis met with cavalry commanders. However, at the same time, the government truly began falling apart. Jefferson Davis wrote to George Davis, the attorney general, on April 25, advising that his services would not be needed and that he should look after his family. George Davis submitted his resignation on April 26. Jefferson Davis left the position open, while at the same time, he turned the government archives over to Adjutant General Cooper. That morning, Davis, with his heads of state, met at the Phifer home. Trenholm had been ill for days. A member of the Phifer family recalled "the flutter of excitement created in the household when word came that there was to be a short meeting of the Cabinet in Mr. Trenholm's room…They remembered seeing these distinguished men, bowed in sorrow come in a body and pass into the sick room to confer together on the last momentous concerns of the 'Lost Cause.'" Johnston, much to the chagrin of Davis, was in the process of surrendering to Sherman at the Bennett farm, and now the Federal armies were just 150 miles away. It was Davis's plan to pass through the Deep South states, making his way to Texas, maybe even as far as Mexico, where he could raise a new army, establish new alliances and continue the struggle for Southern independence. Around noon, about the time that the original truce between Johnston and Sherman was set to expire, Davis, Benjamin, Reagan and Mallory, with an escort of cavalry, rode south out of Charlotte. "There had been some semblance of a capital, some show of governmental routine, some pretense of the power he was elected to wield, up to this," a staff officer wrote after the war. "[B]ut now all that was vanished, and thenceforth the Confederate President was a fugitive, with hardly the shadow of authority. He looked sad, and, indeed, hopeless. Never a word escaped him which betrayed the faintest yielding." Colonel Kean watched the President and his party ride out of town and recalled that this "was the final breaking up of the Confederate government."[140]

For eight days, Charlotte served as the capital of the Confederacy, whose dying hopes were kept alive by the faith that Jefferson Davis had in Southern

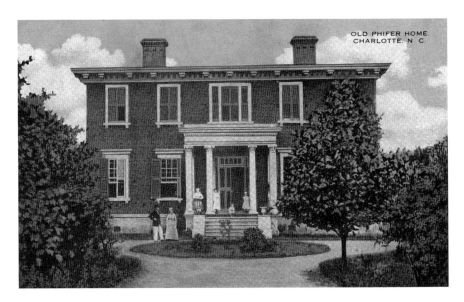

The Phifer House, which sat on North Tryon Street, hosted the last full meeting of the Confederate cabinet on April 26, 1865. *University of North Carolina–Charlotte.*

people. Nevertheless, even Davis was finally forced to admit defeat, at least for a war-torn people. Davis agreed to the terms on April 24 that could have led to his honorable surrender. Yet in reaching such an agreement, the Federal government would have had to acknowledge the Confederacy's sovereignty, something it consistently denied. As Davis rode out of Charlotte, he rode with the knowledge that the two principal Confederate armies in the field had surrendered and that his own cabinet had collapsed. Charlotte truly was the last capital of the Confederacy.

Chapter 7

The Flight of Jefferson Davis

South Carolina to Georgia, April 26 to May 10, 1865

Jefferson Davis's party, containing some three thousand Confederate cavalry, five brigadier generals, the remaining members of his cabinet and aides, along with five wagons and several ambulances, rode out of Charlotte about noon on April 26. That evening, Davis himself stayed at Springfield Plantation, near Fort Mill, while portions of his cabinet and escort camped three miles away at the home of Colonel William E. White. Trenholm was with the group and, with his condition worsening during the night, submitted his resignation the following day. The Trenholms eventually made their way to Columbia, South Carolina, where the former treasury secretary was arrested. Upon accepting Trenholm's resignation, Davis called the remaining cabinet together. Secretary Reagan appeared to be running late, and Davis appointed him acting secretary of the treasury. Reagan protested, saying that his postal department and telegraphic duties were already taxing. Yet Davis held firm, and Reagan then held two cabinet positions. The treasury, Reagan was informed, contained some $800,000 in worthless paper money and $80,000 in gold and silver. Besides Reagan, Davis still had Benjamin, Mallory and Breckinridge with him.[141]

Dr. James R. Bratton hosted Davis on the night of April 27, 1865, in Yorkville (now York), South Carolina. From York, the government crossed the Broad River and had lunch in Unionville (now Union) at the home of former general William H. Wallace. Braxton Bragg, Davis's former military advisor, along with Bragg's wife, joined Davis's party in Unionville. Davis passed by the Cross Keys house on April 30 as the group continued to travel

toward Abbeville, spending that night at the home of Lafayette Young in Laurens County. The night of May 1 was spent in Cokesbury. Finally, early on the morning of May 2, the group rode into Abbeville, where Davis spent a few hours at the Burt-Stark house. Growing discontent among the cavalry escort led Breckinridge to pressure Davis toward calling a council of war. At four that afternoon, seven generals gathered at the Bark house with Breckinridge and Davis. Admitting that the situation looked bleak, Davis still sought to inspire confidence in his generals, reminding them that things were no worse than in the days of the American Revolution. All of the five cavalry commanders were unanimous in their opinion: the Confederacy had no future. The visibly shaken Davis asked them why they stayed on, and they replied that it was to provide him some level of protection while he moved south. Davis soon adjourned the meeting, never to call of a council of war again. His aides and staff worked on lightening their baggage and burning less important papers. They traveled with just one wagon, two ambulances and ten cavalrymen as personal escorts. Three thousand more cavalrymen continued as well, at least for a short while.

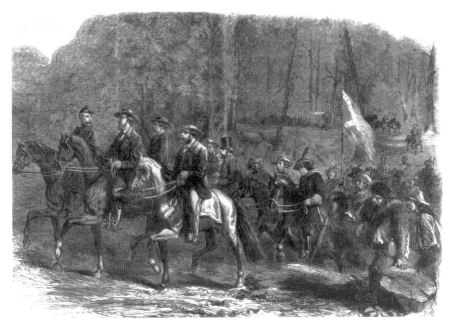

Davis set out from Charlotte on April 26, 1865, not only with the remnants of the Confederate cabinet but also with an escort of three thousand cavalry troops. The cavalry was along only to see to Davis's protection. *Michael C. Hardy.*

With rumors of nearby Federal cavalry, the group chose to leave Abbeville at about 11:00 p.m. They might have moved even more quickly had they known that the United States had issued a $100,000 reward for the arrest of Jefferson Davis. At dawn, Davis crossed the Savannah River. Yet many of the cavalry escort refused to go any farther; only the ten escorting Davis remained. Breckinridge was detained at the river crossing and commenced to pay off the men with Mexican silver dollars. Once paid, the cavalrymen were dismissed and set out in different directions in an attempt to mislead the Federal cavalry. Also giving up the struggle on May 3 was Judah Benjamin. The secretary of state came to Davis, stating that he "could not bear the fatigue of riding as you do, and as I can serve our people no more just now, will you consent to my making an effort to escape through Florida? If you should be in a condition to require me again I will answer your call at once." With that, Benjamin got into his carriage and set out. He reached Florida and departed Sarasota Bay on June 23, 1865, eventually settling in Paris.[142]

Remaining members of the party surrounding Davis arrived in Washington, Georgia, about noon on May 3. Davis's last act as president of the Confederate States of America was the appointment of Micajah Clark as acting treasurer. Additional funds were distributed among the group, with $86,000 loaded into a carriage with a false bottom and sent south. Any additional paper money on hand was burned. On May 4, Davis called his last cabinet meeting. Only Mallory was still present, along with a handful of aides. Reagan could not catch up with the group until nightfall. Davis dissolved the Confederate government, hoping to re-form it when conditions were more favorable. Mallory and former Confederate senator Louis Wigfall set out soon thereafter, bound for Mallory's home near La Grange, Georgia. About midmorning, the much-reduced party set out, camping for the night south of Powelton in Warren County, Georgia.[143]

Hearing that Varina and the rest of his family were just ahead of him, Davis left his escort and rode ahead on May 6. He located them that evening, and they camped just north of Dublin. The two groups traveled together on May 7, and Davis learned that Federal cavalry was close by. On the morning on May 8, Davis set out to put distance between himself and his family, but torrential rains impeded his progress. That evening, the two groups crossed the Ocmulgee River, camping on the south side. On May 9, the two groups traveled together again, this time camping one mile south of Irwinville. It was Davis's intent to leave before dawn so that his family would not be endangered by his presence. Yet before dawn broke, Federal cavalry, having learned of the group's location, surrounded the camp. Just before dawn,

A History

The capture of Davis on May 10 was portrayed in many different ways, including his wearing a dress, trying to evade Federal cavalry. He actually was captured wearing a shawl, but it was not uncommon for men to do so in the 1860s. *Library of Congress*.

gunfire erupted between the two Federal cavalry regiments to the north, while other Federal troopers rode into the camp. Davis attempted to flee the camp but was captured, along with his wife and children and several others. After being allowed to finish breakfast, Davis was escorted north, eventually landing as a prisoner at Fortress Monroe, not far from Richmond.

Chapter 8

Looking for the Capitals of the Confederacy

Every city that served as a Confederate capital or bore witness to the end of the Confederate government has some lingering evidence, large or small, of its moment in history. Some locations embrace and preserve their historic sites related to the war and the Confederacy, using markers, museums and other interpretive tools to commemorate the past. Others have moved on, leaving only faint traces of the past as the world has changed. For the visitor interested in seeing the sites of the Confederate capitals, there are some remaining buildings, as well as markers and museums that denote and preserve the history of the Confederate government and its capitals, ranging from the heady early days to the limping conclusion. While some are easily accessible and visitor friendly, others are not, but there are still plenty of locations that beckon to those hoping to visit the remains of one of the Confederacy's capitals.

MONTGOMERY

Much of wartime Montgomery is gone. No longer present are the Exchange Hotel, where many of the delegates from various states lived and where Jefferson Davis was introduced and spoke to the crowd. Montgomery Hall, where Mary Chesnut chronicled the beginning days of the Confederate government, is also gone. The Exchange was located on Commerce

Street, and Montgomery Hall was on Dexter Avenue. Mrs. Cleveland's boardinghouse is also no longer standing. It was located on the corner of Catoma and Montgomery Streets.

The two-story frame Montgomery and West Point Railroad depot, in which so many hopeful politicians, including Jefferson Davis, arrived and departed, was replaced in 1898. The original depot was located at 300 Water Street. The Central Bank Building (1858), still standing at the corner of Dexter and Court Streets, was the first bank to lend money to the Confederate government. Also at the corner of Dexter Street and Court Square is the Winter Building (1841). This building housed the telegraph offices of the Southern Telegraph Company. Telegrams notifying Jefferson Davis of his election as provisional president of the Confederate States of America, along with authorization for P.G.T. Beauregard to open fire on Fort Sumter in Charleston, were sent from this building. In front of the Alabama Department of Archives and History is the First White House of the Confederacy (1830s). It originally sat on the corner of Bibb and Lee Streets. Jefferson Davis and his family lived in the house for about a month, prior to the capital's moving to Richmond. The house itself was moved to its current location in 1919. Sitting across the street is the Alabama state capitol building (1847). This structure was burned in 1849, rebuilt and served as the first capitol of the Confederacy. There is a bronze star embedded under the portico, denoting the location where Jefferson Davis was inaugurated. The iron fence that surrounded the capitol is now located around the Old Augusta Cemetery on Wares Ferry Road. While in Montgomery, Davis attended St. John's Episcopal Church (1855) at the corner of Madison Avenue and Perry Street. The Murphy House (1851) served as the headquarters of the Union provost marshal when the Federal army visited the city in April 1865 and is still standing. Yet another interesting remaining structure is the William L. Yancey Law Office (1846), at the corner of Washington and Perry Streets. The first Confederate post office department operated out of this building. Old Oakwood Cemetery was established prior to the war. A host of important Confederates are buried here, including Confederate senator William L. Yancey; Congressmen William P. Chilton, David Clopton and Malcom D. Graham; Generals James H. Colton, Birkett D. Fry, Henry W. Hilliard, James T. Holtzclaw and Temmemt Lomax; wartime Alabama governor Thomas H. Watts; and Confederate register of the treasury Robert Tyler.

The Capitals of the Confederacy

Richmond

The war left much of Richmond a mere burned-out shell. All or parts of fifty-four city blocks were lost in the conflagration. It was as if the city was trying to purge itself of the past. Yet some of wartime Richmond survives, including sites connected to its role as the longest-serving Confederate capital.

Possibly the best place to start seeking Richmond's history as a Confederate capital is the Museum of the Confederacy, now a part of the American Civil War Center. The museum, originally in the Confederate White House, which the Ladies' Hollywood Memorial Association saved from demolition, opened in 1896. In 1976, a new building was opened, housing some of the best artifacts of the Confederacy. Some of the highlights include the field equipment of Robert E. Lee, J.E.B. Stuart's plumed hat and Stonewall Jackson's sword. The museum also boasts the largest collection of original Confederate flags, several of which are always on a rotating display. Located next door is the White House of the Confederacy. The house, which is a National Historic Landmark, was restored to its wartime appearance in 1988. The Museum of the Confederacy can be found at 1201 East Clay Street.

Located in the Pattern Building at Tredegar Iron Works is the headquarters for the Richmond National Battlefield Park. The park consists of thirteen units. These units are the battlefields surrounding the city. Among these are Drewry's Bluff on the James River, a fortification that held Union gunboats at bay, and the Cold Harbor Battlefield, where, in 1864, Federal forces sustained twelve thousand killed, wounded, missing and captured in a week's worth of fighting.

There are five remaining buildings from wartime Tredegar Iron Works. Located beside the Richmond National Battlefield Park headquarters is the American Civil War Center. Incorporated in 2000, the site attempts to tell a history of the war from three perspectives: Confederate, Union and African American.

Across the parking lot from the Tredegar site is Brown's Island. The island was home to the Confederate States Laboratory, and it was here that in March 1863 part of the facility exploded, killing forty-five people, mostly women and young girls.

On the other side of the James River from Tredegar is Belle Isle, the site of a Federal prison for portions of the war, but it is not an easily accessible site for visitors.

A few blocks to the northeast is the Virginia state capitol building. This is the building in which Robert E. Lee was offered command of Virginia State forces, Jefferson Davis was sworn in as the first permanent Confederate

A History

Several of the old Tredegar Iron Works buildings were restored by the Ethyl Corporation in the 1970s. In 2000, the National Park Service opened a visitor center in the Pattern Building, and in 2006, the American Civil War Center opened in the Gun Factory. *Michael C. Hardy.*

president and the Confederate Congress met when in session. Tours of the building are available. On the grounds of Capital Square are the Governor's Executive Mansion (1813), where Davis held his first reception; the statue of George Washington; and the bell tower, or tocsin, which called the militia and departmental guards out for duty in the trenches surrounding Richmond. More recent additions to the grounds are statues of Stonewall Jackson, wartime governor William "Extra Billy" Smith and Dr. Hunter McGuire. Across the street from the capital, at 1000 East Main Street, is the United State Customs House (1858). This building was used as offices for various branches of the Confederate government, while also containing the office of Jefferson Davis. It is not open to the public.

There are several surviving buildings in the city that served as hospitals during the war. Centenary United Methodist Church (1843) at 411 East Grace Street; the Egyptian Building (1845), once a part of Medical College of Virginia; and the Old First Baptist Church (1839–41), are just a few. Nothing remains of Chimborazo Hospital. However, the National Park Service operates the Chimborazo Medical Museum in a twentieth-century structure at the hospital's site. Visitors can learn about the hospitals in the Richmond area, along with medical practices of the 1860s.

The Capitals of the Confederacy

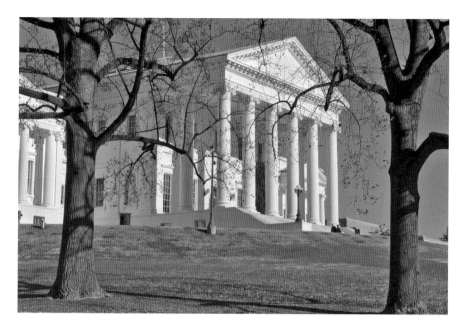

In 1904, the capitol building in Richmond was extensively modified, with the addition of wings and other improvements. The House chamber, where the Confederate Congress met, has been re-created. *Michael C. Hardy.*

St. Paul's Church (1845) still stands at 815 East Grace Street. This was the church attended by Jefferson Davis and Robert E. Lee when they were in the city. Davis was here on April 2, 1865, when he received word that the Federals had broken through Confederate lines below Petersburg, precipitating the evacuation of Richmond.

At 707 East Franklin Street is the Stewart-Lee House (1844–49). The three-story Greek Revival townhouse was rented by Robert E. Lee's son, George Washington Custis Lee, during the war. In 1864, it became the home to Lee's wife, Mary Anna Custis Lee, and his daughters. Mrs. Lee remained at the house when Richmond was evacuated, and it was here that Lee returned after surrendering at Appomattox Court House in April 1865.

Many of Richmond's cemeteries contain the casualties of the war. The Hebrew Cemetery at 400 Hospital Street has the graves of thirty Jewish Confederate soldiers. An ornate iron fence surrounds the cemetery. Across the street from the Hebrew Cemetery is Shockoe Cemetery. There are both Confederate and Union soldiers buried at Shockoe, including over six hundred Federal prisoners of war. Many of the Federals were later moved to the Richmond National Cemetery, but a marker was installed in 2002

with the names of some of the prisoners. Oakwood Cemetery (off Oakwood Avenue) served Chimborazo Hospital. The cemetery was established prior to the war, but sick and wounded Confederates who succumbed to their conditions quickly outnumbered the original departed. There are somewhere around seventeen thousand Confederate soldiers at Oakwood. A nearby historical marker states that, in the weeks following the Seven Days Battles, seventy-five soldiers a day were interred at Oakwood Cemetery.

There is no more hallowed spot in the former Confederacy than Hollywood Cemetery. During the war, the cemetery was forced to acquire additional property to accommodate the number of soldiers dying in local hospitals. There are somewhere around eighteen thousand Confederates interred at Hollywood. Among these are twenty-eight Confederate generals, including Joseph R. Anderson, who ran Tredegar Iron Works; Henry Heth, the only person whom Robert E. Lee called by his first name; George Pickett and his wife, LaSalle; and J.E.B. Stuart, mortally wounded at the Battle of Yellow Tavern in 1864. Among other notables are Confederate president Jefferson Davis, former United States president and Confederate congressman John Tyler and Confederate general and wartime governor of Virginia, William "Extra Billy" Smith. Hollywood Cemetery also contains the graves of both Virginia and unknown Confederate dead from the battlefield of Gettysburg, as well as the remains of Confederate soldiers relocated from Arlington National Cemetery.

Monument Avenue has been declared one of the Ten Great Streets in America. There are larger-than-life statues of Confederate luminaries Jefferson Davis, Robert E. Lee, Stonewall Jackson, J.E.B Stuart and Matthew Maury. A few blocks to the northeast of Monument Avenue, at the intersection of Laburnum and Hermitage Road, is the grave of Confederate lieutenant general A.P. Hill. Hill was killed on April 2, 1865, and originally buried near Bosher's Dam. His remains were transferred to Hollywood Cemetery in 1867 and then to this location in 1891.

DANVILLE

Danville served as the capital of the Confederacy from April 3 to April 10, 1865. The highlight of any visit to Danville is the Sutherlin Mansion (1859), housing the Danville Museum of Fine Arts and History. Jefferson Davis stayed at the Sutherlin Mansion while in Danville and held meetings of the Confederate cabinet at the home. On permanent display is an exhibit

The Capitals of the Confederacy

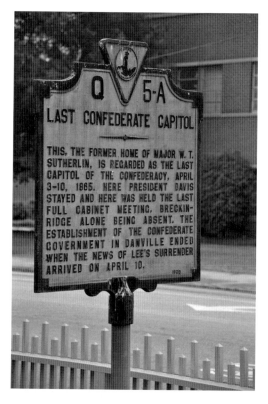

For generations, Danville has proudly proclaimed to be the last capital of the Confederacy, even though the Confederate government functioned in Charlotte for a number of days in late April 1865. *Michael C. Hardy.*

entitled "Between the Lines: Danville 1861–1865." On the grounds of the mansion are several monuments, including one to the "Women of the Southern Confederacy" and several proclaiming Danville as the "Last Capital of the Confederacy."

There are several cemeteries in Danville, including the Danville National Cemetery, containing the graves of 1,323 Federal soldiers who died as prisoners of war in various facilities in Danville, along with the Green Hill Cemetery, where a monument marks the final resting place of 400 Confederate soldiers.

Located at 300 Lynn Street is the only remaining tobacco warehouse used as a prison during the war. Off Craighead Street are descriptive markers telling the story of the Richmond and Danville Railroad, the line that transported Confederate government officials after the evacuation of Richmond on April 2, 1865. There also the remnants of Confederate earthworks off US 58, located on the hills above the Dan River.

Greensboro

While Greensboro contains a great museum with a first-class collection of Confederate artifacts (Greensboro Historical Museum), there is nothing surviving with which Davis and the Confederate government came in contact. There are two North Carolina Historic Site markers in Greensboro.

A History

The Confederate government's stay in Greensboro was short and full of turmoil. There are two markers in Greensboro, within a block of each other, marking the spots where Davis stayed and the rail yard where the majority of the cabinet stayed. *Michael C. Hardy.*

One of them is located on South Elm Street at McGee Street. It reads, "The President of the Confederacy held two meetings of his cabinet, April 12–13, 1865, at the home of J.T. Wood, which was a few yards N." Another marker is also located on South Elm Street, this one at Asheboro Street. It reads, "Confederate Cabinet. Members of the cabinet, fleeing south, occupied a railroad car near this spot, Apr. 11–15, 1865." Well worth a visit is the Greensboro Historical Museum. The John and Isabelle Murphy Confederate Firearms Collection is one of the best in the South. The exhibit also includes original Don Troiani paintings and other artifacts.

Lexington

On US 29, outside Lexington, is a historical marker denoting the site where Davis's group camped on the night of April 16, 1865.

Concord

A state historical marker, on North Union Street, marks the location of a house where Jefferson Davis stayed on April 18, 1875.

CHARLOTTE

There are a couple of markers in Charlotte concerning the work of the Confederate government while the city served as a Confederate capital. This marker is on South Tryon Street. *Brian Duckworth.*

Time has progressed forward at a furious pace in the Queen City, and very little of wartime Charlotte remains. All of the homes that housed Confederate officials have been demolished. The Phifer home was torn down in the late 1940s; the Bates home was gone by the mid-twentieth century; and the old bank building that served as the last capital of the Confederacy, and later as an office for the *Charlotte Observer*, was razed in 1970. There is a bronze plaque at 122 South Tryon Street that marks the spot where the last meeting of the whole Confederate cabinet took place. Embedded in the concrete at Tryon and Fourth Streets is a marker denoting the location where Davis was standing when he received word of Lincoln's assassination. This is also a marker for St. Peter's Episcopal Church, where Davis and members of his cabinet worshiped while in Charlotte.

SOUTH CAROLINA

Davis, a few of the cabinet members, various Confederate generals and an escort of three thousand cavalry moved through South Carolina from April 26 until May 2, 1865. They stopped at various sites along the way. There are historical markers following the route. These include a marker denoting the flight of Jefferson Davis and the last meeting of the Confederate

A History

South Carolina has marked the route of the Confederate government through the state. This marker, denoting where Davis's party passed on April 27, 1865, refers to a meeting of the Confederate cabinet at which Davis replaced secretary of the treasury George Trenholm with John Reagan. *Michael C. Hardy*.

cabinet on SC 160, near the western limits of Fort Mill; on the corner of Eden Tee and Myrtle Drive in Rock Hill; and at 8 Congress Street in York, where Davis spent the night of April 27, 1865. A stone monument sits in front of the Wallace home in Union, South Carolina, marking the location where Davis had dinner on April 28. Another historic marker is at the intersections of SC 56 and Road 38, two and a half miles southwest of Joanna, South Carolina, denoting the spot where Davis slept on the night of April 30.

Abbeville has a couple of historic markers. One, at 306 North Main Street, describes the meeting of Davis and his last council of war on May 2 at the home of Colonel Burt. A second marker is at 400 North Main Street, marking the spot where Davis held his "Last Cabinet Meeting."

Georgia

There are many state historical markers in Georgia commemorating the flight of Jefferson Davis through the state. They often provide a running commentary of Davis's path, stating that he arrived in Washington on May 4, was captured on May 10 and on May 13 traveled through Atlanta, Augusta and Savannah, where he was taken via ship to Fortress Monroe, Virginia.

The Capitals of the Confederacy

Washington, in Wilcox County, has one marker on the courthouse lawn. There are two markers in Washington County. One is located in Sandersville at the Jared Irwin Memorial Park, while the other is on GA 57, just east of 68 East.

There are two markers in Abbeville, Georgia, including a boulder dedicated in 1925 by the local Daughters of the Confederacy, marking the spot where Davis and his party camped on May 9, 1865.

In Eastman, Dodge County, are two markers marking the path of Jefferson Davis. One is a state historical marker on US 23 and GA 87 at the First Baptist Church in Eastman.

There are two Georgia state historical markers on US 319 near Dublin, marking the spot where Davis and his party crossed over the Oconee River.

Jefferson Davis, his family, John Reagan and several others were captured on May 10, 1865, not far from Irwinville, Georgia. Today, a monument marks the spot, surrounded by the thirteen-acre Jefferson Davis Memorial Historic Site. There are three state historic markers within the park, with another located in nearby Irwinville on GA 125 and Jefferson Davis Park Road.

In 1935, a statue of Jefferson Davis, marking the site where he was captured on May 10, 1865, was erected near Irwinville, Georgia. The site today is a state park with not only this monument but a museum as well. *Library of Congress.*

Notes

Chapter 1

1. William C. Davis, *A Government of Our Own: The Making of the Confederacy* (New York: Free Press, 1994), 32; see Rembert Patrick, *Jefferson Davis and His Cabinet* (Baton Rouge: Louisiana State University Press, 1944), 319. Patrick argues that Montgomery "was not commercially important, for its cotton trade had been declining for years."
2. Davis, *Government of Our Own*, 31–37; William Warren Rogers Jr., *Confederate Home Front: Montgomery During the Civil War* (Tuscaloosa: University of Alabama Press, 1999), 3–7.
3. Rogers, *Confederate Home Front*, 20; Davis, *Government of Our Own*, 23.
4. Armand J. Gerson, "The Inception of the Montgomery Convention," *Annual Report of the American Historical Association* (1910): 181–87.
5. Davis, *Government of Our Own*, 44–58.
6. James F. Sulzby, *Historic Alabama Hotels and Resorts* (Tuscaloosa: University of Alabama Press, 1960), 125.
7. Davis, *Government of Our Own*, 44, 48, 54–55, 66.
8. Ibid., 72–74.
9. *Charleston Courier*, February 10, 1861.
10. Davis, *Government of Our Own*, 78–96.
11. Ibid., 123; *Montgomery Advertiser*, February 13, 1861.
12. Thomas Cobb, "The Correspondence of Thomas Reade Rootes Cobb, 1861–1862," *Publications of the Southern History Association* 11 (May 1907):

164; *Charleston Courier*, February 10, 1861, March 19, 1861. Thomas Cobb wrote to his wife Marion on February 6, 1861, "A large delegation is here from Atlanta urging that place for the seat of the Provisional Government."
13. Davis, *Government of Our Own*, 129; William Cooper Jr., *Jefferson Davis, American* (New York: Alfred A. Knopf, 2000), 329; Thomas Cobb to Marion Cobb, February 18, 1861, *Publications of the Southern History Association*, 181; *The Papers of Jefferson Davis*, 13 vols. (Baton Rouge: Louisiana State University Press, 1971–2012), 7:54.
14. Cooper, *Jefferson Davis*, 329; *Union and American* (Nashville, TN), February 19, 1861; Davis, *Government of Our Own*, 164–65. Cooper writes that the procession started at 10:00 a.m.
15. Cobb to Marion Cobb, "Correspondence," February 19, 1861, 184; *Selma Weekly Times*, February 19, 1861; Davis, *Government of Our Own*, 167.
16. Davis, *Government of Our Own*, 182.
17. United States Congress, *Journal of the Congress of the Confederate States of America*, 7 vols. (Washington, D.C., 1904), 1:66, 72–73.
18. C. Vann Woodward, *Mary Chesnut's Civil War* (New Haven: Yale University Press, 1981), 8; Thomas C. De Leon, *Four Years in Rebel Capitals* (Mobile, AL: Gossip Printing Company, 1890), 24; Davis, *Government of Our Own*, 193; John H. Reagan, *Memoirs, With Special Reference to Secession and the Civil War* (New York: Neale Publishing Company, 1906), 125.
19. William H. Russell, *My Diary North and South*, 2 vols. (London, 1863), 172.
20. Lawrence R. Laboda, *From Selma to Appomattox: The History of the Jeff Davis Artillery* (Shippensburg, PA: White Mane Publishing Company, 1994), 3; G. Ward Hubbs, *Guarding Greensboro: A Confederate Company in the Making of a Southern Community* (Athens: University of Georgia Press, 2003), 104; C. Vann Woodward and Elizabeth Muhlenfeld, *The Private Mary Chesnut: The Unpublished Civil War Diaries* (Oxford: Oxford University Press, 1984), 19; Russell, *My Diary*, 176–77.
21. *Charleston Courier*, March 4, 1861; De Leon, *Four Years*, 24.
22. De Leon, *Four Years*, 25; Caleb Huse, *The Supplies for the Confederate Army* (Boston: Press of T.R. Marvin and Son, 1904), 10.
23. Woodward and Muhlenfeld, *Private Mary Chesnut*, 18.
24. For the debate on privateers, see Russell, *My Diary*, 1:175–76.
25. De Leon, *Four Years*, 28.
26. Davis, *Government of Our Own*, 383–86.
27. Varina Davis, *Jefferson Davis: Ex-President of the Confederate States*, 2 vols. (New York: Belford Company, 1890), 2:37; Davis, *Government of Our Own*, 320, 329; Russell, *My Diary*, 177.

28. For examples, see Davis to Pickens, February 20, 1861, and February 22, 1861; *Papers of Jefferson Davis*, 7:55–58.
29. *Richmond Daily Dispatch*, April 9, 1861; Patrick, *Jefferson Davis and His Cabinet*, 112; *Charleston Courier* April 10, 1861; April 15, 1861; De Leon, *Four Years*, 35; Davis, *Government of Our Own*, 311–18.
30. Davis, *Government of Our Own*, 339–40, 343, 345, 376; James D. Richardson, *A Compilation of the Messages and Papers of the Confederacy*, 2 vols. (Nashville, TN: United States Publishing Co., 1906), 1:63.
31. *Charleston Courier*, March 21, 1861; *War of the Rebellion: A Compilation of the Official Records of the Union and Confederate Armies*, 128 vols. (Washington, D.C., 1880–1901), 4:255; Jerrell H. Shofner and William W. Rogers, "Montgomery to Richmond: The Confederacy Selects a Capital," *Civil War History* (June 1964): 159.
32. John B. Jones, *A Rebel Clerk's Diary* (New York: Sagamore Press, Inc., 1958), 20; *Charleston Daily Courier*, May 7, 1861; Woodward, *Mary Chesnut's Civil War*, 62; Shofner and Rogers, "Montgomery to Richmond," 156.
33. *Richmond Dispatch*, May 30, 1861.

Chapter 2

34. *Wilmington Journal*, May 30, 1861; *Richmond Examiner*, May 31, 1861.
35. Thomas S. Kidd, *Patrick Henry: First Among Patriots* (New York: Basic Books, 2011): 98–99; *Papers of Jefferson Davis*, 6:160.
36. Emory M. Thomas, *The Confederate State of Richmond* (Baton Rouge: Louisiana State University Press, 1998), 26, 28; W. Asbury Christian, *Richmond: Her Past and Present* (Richmond, VA: I.H. Jenkins, 1912), 211.
37. Thomas, *Richmond*, 30; Marie Tyler-McGraw, *At the Falls: Richmond, Virginia, and Its People* (Chapel Hill: University of North Carolina Press, 1994), 136.
38. Thomas, *Richmond*, 6–11.
39. *Richmond Dispatch*, May 30, 1861; *Papers of Jefferson Davis*, 7:183; Sallie A. Brock, *Richmond During the War: Four Years of Personal Observation* (New York: G.W. Carleton & Co., 1867), 38.
40. Ernest B. Furgurson, *Ashes of Glory: Richmond at War* (New York: Alfred A. Knopf, 1996), 52; Woodward, *Mary Chesnut's Civil War*, 82; Thomas, *Richmond*, 45; Brock, *Richmond During the War*, 38; *Richmond Dispatch*, June 3, 1861.
41. Richard K. Perkins, *A Brief History of the Lewis F. Powell, Jr., United States Courthouse, 1858–2012* (Richmond, VA, 2012), 4–6; Jones, *Diary*, 22, 24.

42. Jones, *Diary*, 30; De Leon, *Four Years*, 87; *An Official Guide of the Confederate Government from 1861 to 1865 at Richmond; Showing the Location of the Public Buildings and Offices of the Confederate, State, and City Government, Residences of the Principal Officers, etc* (Richmond, VA, [1910?]).
43. *Richmond Daily Dispatch*, June 22, 1861; Timothy L. Wherry, *The Librarian's Guide to Intellectual Property in the Digital Age* (Chicago: American Library Association, 2002), 44; Dallas D. Irvine, "The Fate of Confederate Archives: Executive Office," *American Historical Review* 44, no. 4. (July 1939): 835.
44. *Papers of Jefferson Davis*, 7:184; Catherine C. Hopley, *Life in the South*, 2 vols. (London: Chapman and Hall, 1863), 1:368; Michael C. Hardy, *The Thirty-seventh North Carolina Troops: Tar Heels in the Army of Northern Virginia* (Jefferson, NC: McFarland and Company, 2003), 54.
45. *Richmond Whig*, December 13, 1863; *Richmond Dispatch*, October 10, 1861, July 13, 1861, September 18, 1861.
46. *Richmond Dispatch*, September 18, 1861; May 18, 1862; see Thomas P. Lowery, *The Story the Soldiers Wouldn't Tell: Sex in the Civil War* (Mechanicsburg, PA: Stackpole Books, 1994), 70–72.
47. Judith B. McGuire, *Diary of a Southern Refugee, During the War* (New York: E.J. Hale & Son, 1867), 88; Jones, *Diary*, 27, 28.
48. *Richmond Enquirer*, July 6, 1861.
49. *Richmond Dispatch*, June 1, 1861, June 25, 1861; *Richmond Enquirer*, June 15, 1861; Furgurson, *Ashes of Glory*, 58; Rebecca Calcutt, *Richmond's Wartime Hospitals* (Gretna, VA: Publican Publishing Company, 2005), 139.
50. Jones, *Diary*, 34; Fannie A. Beers, *Memories: A Record of Personal Experience and Adventure During Four Years of War* (Philadelphia: J.B. Lippincott Co., 1888), 25.
51. *Richmond Dispatch*, June 1, 1861, July 22, 1861, July 23, 1861; Calcutt, *Wartime Hospitals*, 141.
52. *Richmond Examiner*, July 24, 1861, July 25, 1861.
53. *Richmond Dispatch*, July 24, 1861; Chesnut, *Diary*, 105–7; Jones, *Diary*, 35.
54. *Richmond Examiner*, July 24, 1861.
55. Jones, *Diary*, 37; *Richmond Examiner*, July 25, 1861; J.L. Burrows, "Recollections of Libby Prisons," *Southern Historical Society Papers* 11 (February–March 1883): 83–84.
56. Charles Lanman, ed., *Journal of Alfred Ely: A Prisoner of War in Richmond* (New York: D. Appleton and Company, 1862), 18–40.
57. De Leon, *Four Years*, 88; Wilfred Buck Yearns, *The Confederate Congress*. (Athens: University of Georgia Press, 1960), 13–14.
58. Varina Davis, "The White House of the Confederacy," *Frank Leslie's Popular Monthly* 41, no. 5 (May 1896): 509–10; Cooper, *Jefferson Davis*, 367–68.

59. Jones, *Diary*, 54; *Richmond Dispatch*, December 12, 1861; Thomas, *Richmond*, 73–74; William J. Kimball, *Starve or Fall: Richmond and Its People, 1861–1865* (Ann Arbor, MI: University Microfilms International, 1976), 74.
60. Calcutt, *Wartime Hospitals*, 151–83.
61. Furgurson, *Ashes of Glory*, 110–11; Constance Cary Harrison, *Recollections Grave and Gay During the Late War* (New York: Charles Scribner's Sons, 1911), 69.
62. Jones, *Diary*, 76; Thomas, *Richmond*, 92–96; Furgurson, *Ashes of Glory*, 130–34.
63. *Richmond Sentinel*, October 6, 1862; Calcutt, *Wartime Hospitals*, 144–45.
64. Jones, *Diary*, 82; Sallie B. Putnam, *Richmond During the War: Four Years of Observation by a Richmond Lady* (N.p.: G.W. Carleton, 1867), 151.
65. *Richmond Enquirer*, June 24, 1862; Mary H. Mitchell, *Hollywood Cemetery: The History of a Southern Shrine* (Richmond: Virginia State Library, 1986), 50–53.
66. Lonnie R. Speer, *Portals to Hell: Military Prisons of the Civil War* (Lincoln: University of Nebraska Press, 2005), 92–93.
67. Warren Goss, *The Soldier's Story of His Captivity at Andersonville, Belle Island, and Other Rebel Prisons* (Boston: Lee and Shepard, 1867), 35–36.
68. Jones, *Diary*, 104, 105; Thomas, *Richmond*, 87, 105.
69. Thomas E. Schott, *Alexander L. Stephens of Georgia: A Biography* (Baton Rouge: Louisiana State University Press, 1988), 433.
70. *Richmond Dispatch*, April 4, 1862; McGuire, *Diary*, 252.
71. *Richmond Dispatch*, May 19, 1862; *Richmond Examiner*, May 26, 1862, April 14, 1863, September 3, 1863, November 18, 1863.
72. H.H. Cunningham, *Doctors in Gray: The Confederate Medical Service* (Baton Rouge: Louisiana State University, 1958), 196; Calcutt, *Wartime Hospitals*, 71; *Richmond Examiner*, December 29, 1862.
73. Mrs. Roger A. Pryor, *Reminiscences of Peace and War* (New York: Grosset and Dunlap, 1905), 238; Jones, *Diary*, 183; Furgurson, *Ashes of Glory*, 193–94.
74. Furgurson, *Ashes of Glory*, 195–96.
75. James I. Robertson, *Stonewall Jackson: The Man, the Soldier, the Legend* (New York: MacMillan Publishing, 1997), 756–59.
76. Calcutt, *Wartime Hospitals*, 82; Jones, *Diary*, 242.

Chapter 3

77. Thomas, *Richmond*, 136–38; De Leon, *Four Years*, 318; Jones, *Diary*, 235–37; *A Survey of Civil War Sites in Hanover County, Virginia* (Hanover, VA: Hanover County Historical Commission, 2002), 29–31.

78. Frank E. Vandiver, ed., *The Civil War Diary of General Josiah Gorgas* (Tuscaloosa: University of Alabama Press, 1947), 55; Furgurson, *Ashes of Glory*, 214.
79. *Richmond Dispatch*, July 8, 1863; Edwin C. Fishel, *The Secret War for the Union* (New York: Houghton Mifflin Company, 1996), 85, 257; Thomas, *Richmond*, 83.
80. Furgurson, *Ashes of Glory*, 117, 121; Frances H. Casstevens, *George W. Alexander and Castle Thunder* (Jefferson, NC: McFarland and Company, 2004), 47, 82; Speer, *Portals to Hell*, 95.
81. Casstevens, *George W. Alexander*, 88–91; Speer, *Portals to Hell*, 232–33.
82. Joseph Wheelan, *Libby Prison Breakout: The Daring Escape from the Notorious Civil War Prison* (New York: Public Affairs, 2010), 90.
83. *Richmond Examiner*, November 23, 1863; Kenneth Radley, *Rebel Watchdog: The Confederate States Army Provost Guard* (Baton Rouge: Louisiana State University Press, 1989), 173; Joseph George Jr., "Black Flag Warfare: Lincoln and the Raids Against Richmond and Jefferson Davis," *Pennsylvania Magazine of History and Biography* 115, no. 3 (July 1991): 293–98.
84. George, "Black Flag Warfare," 308–11.
85. Furgurson, *Ashes of Glory*, 248–49; Cooper, *Jefferson Davis*, 429; Radley, *Rebel Watchdog*, 175.
86. Jones, *Diary*, 367–78; *Richmond Examiner*, May 16, 1864.
87. Chris Ferguson, *Hollywood Cemetery, Her Forgotten Soldiers: Confederate Field Officers at Rest* (N.p., 2001), 19; *Richmond Whig*, May 9, 1864, May 13, 1864.
88. Burke Davis, *Jeb Stuart: The Last Cavalier* (New York: Bonanza Books, 1957), 419; *Richmond Whig*, May 14, 1864.
89. *Richmond Examiner*, May 17, 1864; *Richmond Sentinel*, May 21, 1864.
90. Harrison, *Recollections Grave and Gay*, 182–83.
91. *Richmond Sentinel*, May 25, 1864; *Richmond Whig*, May 26, 1864; *Richmond Examiner*, May 28, 1864.
92. *Richmond Examiner*, June 18, 1864.
93. Larry Daniel and Riley Gunter, *Confederate Cannon Foundries* (Union City, TN: Pioneer Press, 1977), 93; *Richmond Daily Dispatch*, July 22, 1863, November 4, 1863; Thomas, *Richmond*, 117.
94. Midori Takagi, *Rearing Wolves to Our Own Destruction: Slavery in Richmond, Virginia, 1782–1886* (Charlottesville: University Press of Virginia, 1999), 124–44.
95. Edward Younger, ed., *Inside the Confederate Government: The Diary of Robert Garlick Hill Kean* (New York: Oxford University Press, 1957), 464.
96. Jones, *Diary*, 443; Brock, *Richmond During the War*, 303; Thomas, *Richmond*, 185.

97. Edward Alfriend, "Social Life in Richmond," *Cosmopolitan* 11 (N.d.): 230; Phoebe Pender, *A Southern Woman's Story* (New York: G.W. Carleton & Co., 1879), 165; Furgurson, *Ashes of Glory*, 297–98.
98. Furgurson, *Ashes of Glory*, 278; De Leon, *Four Years*, 317.
99. Jones, *Diary*, 465, 478; *Richmond Dispatch*, February 22, 1865, March 6, 1865; Furgurson, *Ashes of Glory*, 303; John Leyburn, "The Fall of Richmond," *Harper's New Monthly Magazine* 33 (1866): 92.
100. Furgurson, *Ashes of Glory*, 321; John Taylor Wood Papers, #2381, Southern Historical Collection, University of North Carolina–Chapel Hill, Diary, 1.
101. McGuire, *Diary*, 344; Pember, *Southern Woman's Story*, 68; De Leon, *Four Years*, 356.
102. Leyburn, "Fall of Richmond," 94; De Leon, *Four Years*, 361–62; Furgurson, *Ashes of Glory*, 339.
103. Furgurson, *Ashes of Glory*, 336.

Chapter 4

104. F. Lawrence McFall Jr., *Danville in the Civil War* (Lynchburg, VA: H. Howard, 2001), 3, 14, 21, 23–24, 29.
105. McFall, *Danville*, 84; H.W. Bruce, "Some Reminiscences of the Second of April, 1865," *Southern Historical Society Papers* 9, 209; Stephen R. Mallory, Diary and Reminiscences (Southern Historical Collection, University of North Carolina–Chapel Hill), 53; Jefferson Davis, *The Rise and Fall of the Confederate Government* (New York: Da Capo Press, 1881, 1990), 2:573; Anna Trenholm, Diary (Southern Historical Collection, University of North Carolina–Chapel Hill), 1; Michael R. Ballard, *A Long Shadow: Jefferson Davis and the Final Days of the Confederacy* (Jackson: University Press of Mississippi, 1997), 53. Ballard writes that the killed soldiers were actually from Alabama.
106. McFall, *Danville*, 85; John H. Brubaker III, *The Last Capital: Danville, Virginia, and the Final Days of the Confederacy* (Danville, VA: Danville Museum of Fine Arts and History, 1996), 19.
107. *New York Herald*, "The Flight of Jeff. Davis," quoted in *Cleveland Daily Leader*, July 7, 1865.
108. Wood, Diary, April 4, 1865; Kean's quotation is from his diary, found quoted in the *Danville Bee*, June 5, 1957; *New York Herald*, "Flight of Jeff. Davis."
109. Robert Withers, *Autobiography of an Octogenarian* (Roanoke, VA, 1907), 214. One estimate places the size of the naval contingent in Danville

at five hundred men. See James Conrad, *Rebel Reefers: The Organization and Midshipmen of the Confederate States Naval Academy* (New York: Da Capo Press, 2003), 91.
110. Davis, *Rise and Fall*, 2:573–74; *Papers of Jefferson Davis*, 11:501–3. Davis's proclamation was printed in the *Daily Progress* (Raleigh) on April 10, 1865.
111. Wood, Diary, April 5, 1865; *Papers of Jefferson Davis*, 11:509; Mallory, Diary and Reminiscences, 54; Ballard, *Long Shadow*, 59.
112. John S. Wise, *The End of an Era* (Boston, 1899), 446–47.
113. *Danville Bee*, June 5, 1957; *Cleveland Daily Leader*, July 7, 1865; Bruce, "Some Reminiscences," 210; Mallory, Diary and Reminiscences, 59. Another source places Davis at dinner when word arrived of Lee's surrender, with the cabinet meeting convening soon thereafter. See *The Index-Journal* (Greenwood, SC), June 11, 1939.
114. McFall, *Danville*, 93–94; Brubaker, *Last Capital*, 57.
115. McFall, *Danville*, 95; Trenholm, Diary, 1; *Cleveland Daily Leader*, July 7, 1865; Mallory, Diary and Reminiscences, 60.
116. *Official Records*, vol. 46, pt. 3, 1394; *Cleveland Daily Leader*, July 7, 1865; Burton N. Harrison, "The Capture of Jefferson Davis," *Century Illustrated Monthly Magazine* 27, no. 1 (November 1883): 132.

Chapter 5

117. Ethel Stephens Arnett, *Greensboro, North Carolina* (Chapel Hill: University of North Carolina Press, 1955), 23, 74, 167.
118. Another estimate given is one hour. See Robert M. Dunkerly, *The Confederate Surrender at Greensboro* (Jefferson, NC: McFarland and Company, 2013), 45; Mallory, "Last Days of the Confederate Government," 107; Robert L. Phillips, *History of the Hospitals in Greensboro* (Greensboro, NC: Printworks, 1996), 4.
119. "Athos," "Greensboro in Apr. 1865," *Greensboro Patriot*, March 29, 1866. Athos has been identified as James R. Cole; Ethel Stephens Arnett, *Confederate Guns Were Stacked at Greensboro, North Carolina* (Greensboro, NC: Piedmont Press, 1965), 138, note 6.
120. Mallory, Diary and Reminiscences, 68; Harrison, "Capture of Jefferson Davis," 132–33.
121. Mallory, "Last Days of the Confederate Government," 107; Mallory, Diary and Reminiscences, 61–62.

122. *Official Records*, vol. 47, pt. 3:787–88.
123. Alfred Roman, *The Military Operations of General Beauregard in the War Between the States*, 2 vols. (New York: Harper and Brothers, 1884), 2:390–91.
124. Davis, *Rise and Fall*, 2:576; Joseph E. Johnston, *Narrative of Military Operations During the Civil War* (New York: Da Capo Press, 1990), 397.
125. Johnston, *Narrative*, 397–98.
126. Reagan, *Memoirs*, 199; Johnston, *Narrative*, 399; Davis, *Rise and Fall*, 2:577.
127. Mallory, "Last Days of the Confederate Government," 242; Harrison, "Capture of Jefferson Davis," 134; Markinfield Addey, *Life of Jefferson Davis* (Philadelphia: Keystone Pub. Co., 1890), 183; Aspirate, "The Dissolution of the Confederacy," originally printed in *London Times*, the *Cincinnati Enquirer*, November 22, 1865.
128. Harrison, "Capture of Jefferson Davis," 135–36; Wood, Diary, April 15, 1865, April 17, 1865; Aspirate, "Dissolution of the Confederacy"; Addey, *Life of Jefferson Davis*, 183; Davis, *Rise and Fall*, 2:579.
129. Aspirate, "Dissolution of the Confederacy"; Harrison, "Capture of Jefferson Davis," 135. Harrison writes that the gift of the filly took place at the Barringers' home.
130. Mallory, "Last Days of the Confederate Government," 242.

Chapter 6

131. Michael C. Hardy, *Civil War Charlotte: The Last Capital of the Confederacy* (Charleston, SC: The History Press, 2012); Ballard, *Long Shadow*, 25.
132. Irvine, "Fate of Confederate Archives," 823–41; William Parker, *Recollections of a Confederate Naval Officer* (Annapolis, MD: Naval Institute Press, 1985), 272; *Official Records*, vol. 47, pt. 3, 520; *Clarksville Tobacco Plant*, quoted in the *Daily Progress* (Raleigh, NC), April 10, 1865. It was not unusual for period newspapers to quote one another or even lift articles wholesale from other publications.
133. *Charlotte News*, June 22, 1913; *Charlotte Democrat*, January 7, 1868, June 17, 1881; *Charlotte Observer*, January 20, 1895; Davis, *Rise and Fall*, 2:579–80.
134. *Charlotte Observer*, May 20, 1896, July 18, 1916, April 20, 1905; *Charlotte News*, October 7, 1915; Wood, Diary, April 19, 1865. The offices of the *Charlotte Observer* later occupied the bank building. In October 1915, a plaque was erected on the building denoting its importance; Josiah

Gorgas, "Confederate Ordnance Department," *Southern Historical Society Papers* 12 (January–February 1884): 91.
135. William T. Sherman, *Memoirs of General William T. Sherman*, 2 vols. (New York: D. Appleton and Company, 1875), 2:346–47; Cooper, *Jefferson Davis*, 526. Cooper writes that the letter to Sherman was actually dictated by Jefferson Davis.
136. Johnston, *Narrative*, 402; Sherman, *Memoirs*, 2:356–57.
137. *Papers of Jefferson Davis*, 11:555, 565; *Official Records*, vol. 47, pt. 3:823.
138. *Papers of Jefferson Davis*, 11:559.
139. *Official Records*, vol. 47, pt 3:834; Aspirate, "Dissolution of the Confederacy."
140. *Official Records*, vol. 47, pt. 3:835; Addey, *Life of Jefferson Davis*, 184; Mrs. James A. Fore, "Cabinet Meeting in Charlotte," *Southern Historical Society Papers* 3 (September 1916): 61–67. Some sources leave Trenholm in Charlotte. If he was too unwell to meet with Davis and the cabinet at the government office just a few miles away, it is unlikely he was capable of traveling with Davis. Other sources claim Trenholm went as far as Fort Mill, South Carolina, where he resigned on April 27. See *Papers of Jefferson Davis*, 11:519; Kean, *Inside the Confederate Government*, 207; Trenholm, Diary, 3.

Chapter 7

141. Ballard, *Long Shadow*, 117–18; Clint Johnson, *Pursuit: The Chase, Capture, Persecution, and Surprising Release of Jefferson Davis* (New York: Citadel Press Books, 2008), 151.
142. Eli N. Evans, *Judah P. Benjamin: The Jewish Confederate* (New York: Free Press, 1988), 312.
143. Ballard, *Long Shadow*, 130–36.

Index

A

Abbeville, SC 101, 102, 113
Atlanta, GA 12, 19, 28, 29, 31, 64, 113

B

Beauregard, P.G.T. 27, 28, 40, 41, 79, 86, 87, 88, 90, 105
Benjamin, Judah 21, 37, 41, 49, 72, 77, 79, 80, 81, 82, 85, 87, 88, 89, 90, 95, 97, 98, 100, 102
Bragg, Braxton 25, 66, 100
Breckinridge, John 74, 79, 85, 86, 87, 88, 89, 90, 94, 95, 96, 97, 98, 100, 101, 102

C

Charlotte, NC 7, 8, 9, 73, 89, 90, 91, 92, 94, 95, 96, 98, 100, 112
Chesnut, Mary 14, 22, 24, 29, 34, 42, 43, 104
Cobb, Howell 14, 15, 16, 17, 18, 19, 21, 29
Cobb, Thomas 14, 19, 21
Concord, NC 90, 111
Cooper, Samuel 25, 29, 79, 82, 89, 90, 98

D

Dahlgren, Ulric 63
Danville, VA 7, 8, 9, 72, 74, 76, 77, 78, 79, 80, 82, 84, 86, 89, 90, 94, 109, 110
Davis, George 79, 90, 95, 97, 98
Davis, Jefferson 7, 10, 11, 14, 18, 21, 24, 25, 26, 31, 43, 57, 58, 65, 71, 91, 94, 98, 100, 102, 104, 105, 106, 107, 108, 109, 111, 112, 114
Davis, Varina 24, 40, 41, 49, 92
Dublin, GA 102, 114

F

Fort Mill, SC 100

G

Gorgas, Josiah 60, 95
Greensboro, NC 7, 8, 9, 77, 83, 84, 85, 86, 87, 89, 90, 92, 110

H

hospitals 42, 47, 50, 51, 55, 58, 60, 66, 77, 92, 107
Hunter, Robert 49

INDEX

I
Irwinville, GA 102

J
Jackson, Thomas J. 16, 51, 57, 58, 106, 107, 109
Jamestown, NC 32, 89
Johnston, Joseph 49, 50, 77, 85, 86, 87, 88, 89, 90, 94, 96, 97, 98

L
Lee, Robert 40, 50, 51, 57, 58, 59, 60, 61, 63, 64, 65, 66, 67, 70, 72, 78, 80, 81, 82, 83, 84, 86, 87, 89, 96, 105, 106, 108, 109
Letcher, John 34, 50, 57, 72
Lexington, NC 90, 111
Lincoln, Abraham 12, 13, 24, 26, 27, 29, 33, 62, 63, 72, 90, 94, 112

M
Mallory, Stephen 21, 35, 37, 49, 77, 79, 80, 81, 82, 84, 85, 86, 87, 88, 89, 90, 95, 97, 98, 100, 102
Mayo, Joseph 34, 42, 57, 72, 73
Memminger, Christopher 14, 16, 17, 18, 21, 22, 35, 49
Montgomery 7, 8, 9, 11, 12, 13, 14, 15, 17, 18, 19, 21, 22, 23, 24, 25, 26, 27, 28, 29, 30, 32, 35, 39, 40, 67, 97, 104, 105

P
Pember, Phoebe 73
Petersburg, VA 34, 42, 55, 70, 72, 84, 108
prisons 30, 41, 52, 58, 60, 62, 106, 110

R
railroads 8, 12, 42, 50, 59, 60, 70, 74, 77, 84, 94, 105, 110
Randolph, George 49, 66

Reagan, John 21, 23, 49, 72, 79, 82, 85, 87, 88, 89, 90, 95, 96, 97, 98, 100, 102, 114
Richmond, VA 7, 8, 9, 28, 29, 31, 32, 33, 34, 35, 37, 38, 39, 40, 41, 42, 43, 44, 45, 47, 49, 50, 51, 54, 55, 57, 58, 59, 60, 61, 62, 63, 64, 65, 66, 67, 68, 69, 70, 71, 72, 73, 74, 76, 77, 78, 79, 82, 89, 91, 94, 103, 105, 106, 107, 108, 110

S
Salisbury, NC 90
Stephens, Alexander 14, 16, 17, 18, 19, 25, 29, 47, 54, 72
Stoneman, George 84, 91
Stuart, J.E.B. 65, 66, 106, 109

T
Toombs, Robert 14, 21, 22, 25, 27, 29, 35, 36, 49
Trenholm, George 77, 79, 82, 85, 87, 89, 92, 95, 98, 100
Tuscaloosa, AL 11, 28

V
Van Lew, Elizabeth 60, 62

W
Walker, Leroy 21, 27, 29, 35, 41, 49, 61
Washington, GA 102, 113, 114
Winder, John H. 53

Y
Yancey, William 14, 16, 19, 72, 105
York, SC 100

About the Author

Michael C. Hardy is an award-winning Civil War author and historian whose books and articles have examined Confederate regiments, battles, places and personalities. He is a graduate of the University of Alabama and, in 2010, was honored as the North Carolina Historian of the Year. Since 1995, Michael has called the mountains of western North Carolina home. In addition to researching and writing, he enjoys traveling, hiking and photography.

Visit us at
www.historypress.net

This title is also available as an e-book